What I Keep

Photographs of the New Face
of Homelessness and Poverty

SUSAN MULLALLY

What
I Keep

Photographs of the New Face
of Homelessness and Poverty

BAYLOR UNIVERSITY PRESS

Cover & Book Design by Virginia Green
Cover Image by Susan Mullally

All photos are courtesy of the author.

Library of Congress Cataloging-in-Publication Data

Mullally, Susan.
 What I keep : photographs of the new face of homelessness and poverty / Susan Mullally.
 p. cm.
ISBN 978-1-60258-316-0 (hardback : alk. paper)
1. Homelessness--Texas--Waco--Pictorial works. 2. Homeless persons--Texas--Waco--Pictorial works. 3. Poverty--Texas--Waco--Pictorial works. I. Title.
 HV4506.W13M85 2010
 305.5'69209764284--dc22
 2010015545

Printed in the United States of America on acid-free paper.

Dedication

Dedicated to Jimmy and Janet Dorrell and the members of Church Under the Bridge Waco, Texas.

Acknowledgments

I want to acknowledge and thank each member of Church Under the Bridge who trusted and participated in this work. Over three years, sixty people shared their objects, their stories and their friendship.

What I Keep has had many supporters and I thank them all. I want to thank especially Dr. Elizabeth Moran and Christopher Newport University for the first solo exhibition of this work. At Baylor University, I want to thank Dr. Carey Newman at Baylor University Press, Dr. Stephen Sloan of the Institute of Oral History and Terry Goodrich at Media Communications for their direction and help toward publication. My colleagues, Virginia Green and Bob Smith were essential to the production of the book and exhibition, and Diane Smith, Dr. Katie Edwards and Dr. Lisa Shaver provided valuable editing for this book. I also want to thank Duke University, Guilford College, Penn State, the Beijing Studio Center, The Center for Fine Art Photography, East Carolina University, The University of Texas San Antonio, Murray State University and the Wichita Falls Museum of Art, and the Croft Gallery, for the opportunity to exhibit this work.

Baylor University and the Allbritton Art Institute generously supported my research and my friends and colleagues pitched in to help make it all happen.

Susan Mullally

Exhibitions	*Solo shows*	*Group shows*
	Christopher Newport University	Beijing Studio Center
	Duke University	East Carolina University
	Guilford College	Murray State University
	Penn State University	Wichita Falls Museum of Art
	The Croft Gallery	Center for Fine Art Photography
		Baylor University

Contents

What I Keep So You Can See Me

Susan Mullally's unforgettable color photographs of people who gather together in the Church Under the Bridge beneath Interstate 35 make visible something we usually choose not to see. There is a young woman holding a photograph of her sweet baby girl with whom she cannot live because she does not have a place to live. There is a picture of an African American woman holding her junior high school diploma. This is the first time the woman has ever shown it to anyone. There is an unemployed carpenter who collects any stuffed animals he finds so he can give them to the children he encounters during his homeless days. Most of us do not relate to these people because we have jobs, homes, families with whom we live, and a comfortable routine. If we practice a faith with others, we probably worship in a temperature-controlled interior environment that provides shelter, warmth, and a refreshing respite from the natural elements and a welcome and deliberate pause in our daily patterns of behavior, usually with people who fall into similar ethnic, financial, and political categories. According to their Web site, Church Under the Bridge is "an ordinary church made holy by His presence—black, white, brown, rich and poor, educated in the streets and in the university, all worshipping the living God, who makes us one."

What *we* keep exceeds Mullally's frame and is thus left out. In these pictures, she is not interested in the glut of consumption, our wasteful and luxurious ways, and our individual success stories and privileged positions from which we pass judgment or remain passive. Mullally is interested in how people survive, how they form communities, how they hold on to one single thing that becomes a symbol of pride, identity, generosity, memory, and faith. While I may not relate to the people in this book, I feel as if I know more about each of them because of Mullally's images. A Vietnam veteran's army hat places a homeless man in a very specific history and culture, in a certain political situation— one of a broken health care system that fails even for those who almost died "serving their country," a capitalist system that relies on the suffering of some for the pleasure and profit of others.

Working in the tradition of August Sander, Lewis Hine, Diane Arbus, and Rineke Dijkstra, Mullally knows she is swimming in troubled waters. Susan Sontag asks the challenging question in *Regarding the Pain of Others*, "What does it mean to protest suffering, as distinct from acknowledging it?" I am not sure these photographs answer this question, but acknowledging a problem is at the very least a beginning to the solution. Mullally's photographs move us. They create a spark of recognition, of empathy. None

of us can act compassionately without empathy. Unlike the aforementioned photographers, Mullally is not making an archive of archetypes; she is not aligned with a political party or working toward the passage of a specific law (although perhaps she should be); she does not consider her subjects as freaks. She is making photographs as a good citizen, as a concerned woman, as someone searching for community in the small and strange town of Waco, Texas, where Mullally teaches at Baylor University. Mullally respects her subjects, many of whom lead lives constantly disrupted by serious challenges such as homelessness, incarceration, drug addiction, alcoholism, mental illness, and poverty. Mullally simply asks each person what he or she keeps and why it is valued, and she makes a color photograph of the person holding that object of subjective value.

Mullally participates in the Sunday service regularly. She started attending when she first moved to Waco and began teaching at Baylor. She wanted to get to know some people, so she volunteered to take the black and white photographs of members for the church's cherished annual directory. While performing her service for the church, Mullally had the idea for *What I Keep* and was able to gather willing participants for the project. It is noteworthy that this project grew organically and sincerely out of Mullally's own spiritual and community practice and *not* out of a superficial art world desire. I appreciate being introduced to these anti-heroes, these survivors, my fellow citizens. We all need to be reminded, even if we are acutely aware through personal experience, of other people's struggles and difficult situations—often as a result of other people's selfish and greedy ways of life. I look into their eyes and recognize that in these bankrupt and corrupt times of recession and foreclosures, their eyes could one day be our eyes—open and pleading, reconciled and tired, searching and resolved. This is all so close to home. Indeed, many of us drive over such bridges every day—on our way to work or the grocery store. Little do we know that there are people gathering underneath us to join in worship. It is hard to imagine worshipping in such a state (both in terms of personal desperation and need and in terms of actual geographical location), but they do it and seemingly with joy. I once heard Toni Morrison speak about how, if we do not take care of the poor and oppressed, they will rise up and eat us. It is easier for me to imagine people gathering together to plot their cannibalistic feast, but that is the difference between Susan Mullally's visionary spirit and mine, perhaps even yours.

It is dangerous to address faith in one's art. Religion, or ideology, is at the root of every war. Some of us are atheists, agnostics, Jewish, Catholic, Muslim, and Baptist. Some of us just don't care about religion one way or another. Somehow, even though Mullally's subjects all belong to the same church, the pictures do not feel religious, even the one of a woman holding out a crucifix. She could be holding a baby or crutch, a broom or an instrument, and I suppose a crucifix could be any of these things. This church under the bridge feels more like an umbrella organization for people who need each other, who may have a whole lot to give or to receive. I wonder if they each take turns at being the minister or reverend or priest. Mullally could have just as easily chosen to photograph a group of similar people at a homeless shelter or soup kitchen, but she chose to find them in a place to which they choose to go, a place where there is hope and a sense of community.

While the church is nondenominational, it *is* Christian. Having been raised in an unusual politically active Catholic family, I have always imagined the true Christian to be someone who feeds the hungry, clothes the naked, loves their enemies, and gives to the poor. In the United States of America, as an inherent part of their religious beliefs, interpretations, and practices, some Christians seemingly hate homosexuals, believe in forcing women to give birth to unwanted babies, support endless war that we all know kills more civilians than soldiers or terrorists, work toward wealth, and give little to charity. Of course there are other Christians who attempt to mirror Jesus, the humble socialist carpenter, but the loudest ones are the ones we hear. I have no idea what political beliefs the people in Mullally's photographs hold or if they can vote and, if they do, for whom. It doesn't really matter. What matters is that they are people living in our country and we should care about them. If we don't, who will? If we don't care about them, how can we care about each other or ourselves? Our denial and greed lead us, involuntarily or not, to inequality, injustice, and suffering, whether or not we acknowledge it. I am waiting to be devoured, but not by the people who stare out at me from Mullally's photographs. We will devour ourselves.

elin o'Hara slavick
2009

elin o'Hara slavick is Distinguished Professor of Studio Art, Theory and Practice at the University of North Carolina at Chapel Hill. She is the author of *Bomb After Bomb: A Violent Cartography* (CHARTA, 2007). Her work has been exhibited internationally.

What I Keep

Portraits & Choices

My work explores ideas of class, race, ownership, value, and cultural identification.

I collaborate with a community of difference: many races, backgrounds, and lifestyles. Many of the people have had significant disruptions in their lives, experienced periods of homelessness or incarceration, addiction to drugs and alcohol, mental illness or profound poverty and hopelessness, or just made bad decisions. They meet on Sunday mornings at Church Under the Bridge (under Interstate 35), a non-denominational, multicultural church that has been gathering there for seventeen years. I ask each person what he or she keeps and why it is valued.

This is a collaborative project that is in its third year. The work includes 60 portraits with personal statements about each choice. The images are printed life-size (28"x42" pigment prints) for exhibition.

Susan Mullally
2010

www.susanmullally.com

Mark Krim

Kitchen Staff
World Cup Café
2007

"I tell you one thing — all these people have to have their ID — their wallet.

It's your personal safe."

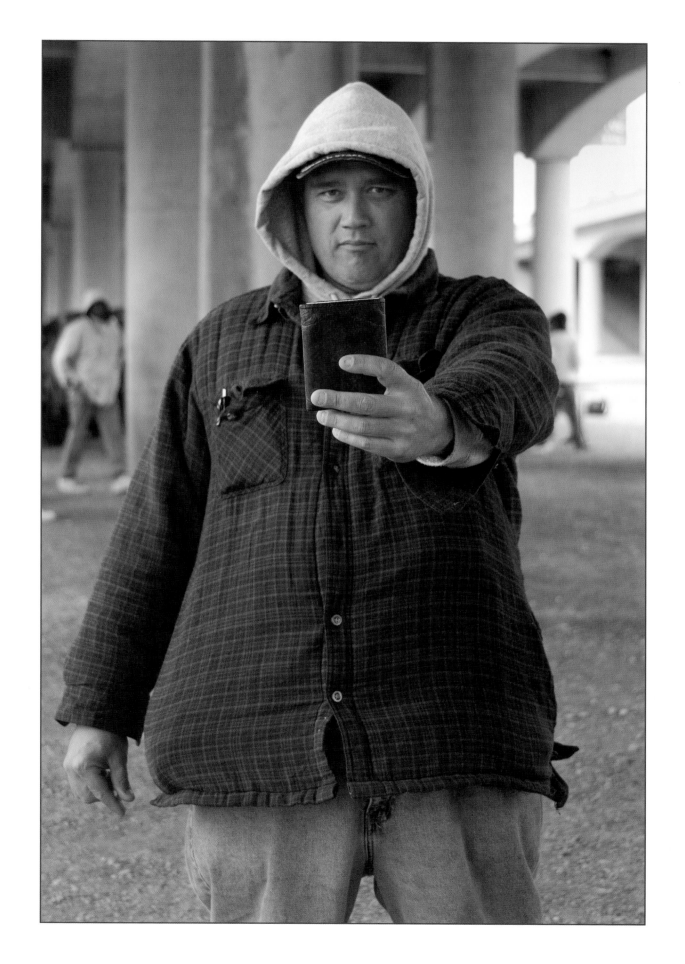

Lisa Clater

Disabled
2008

"I keep a key to my apartment."

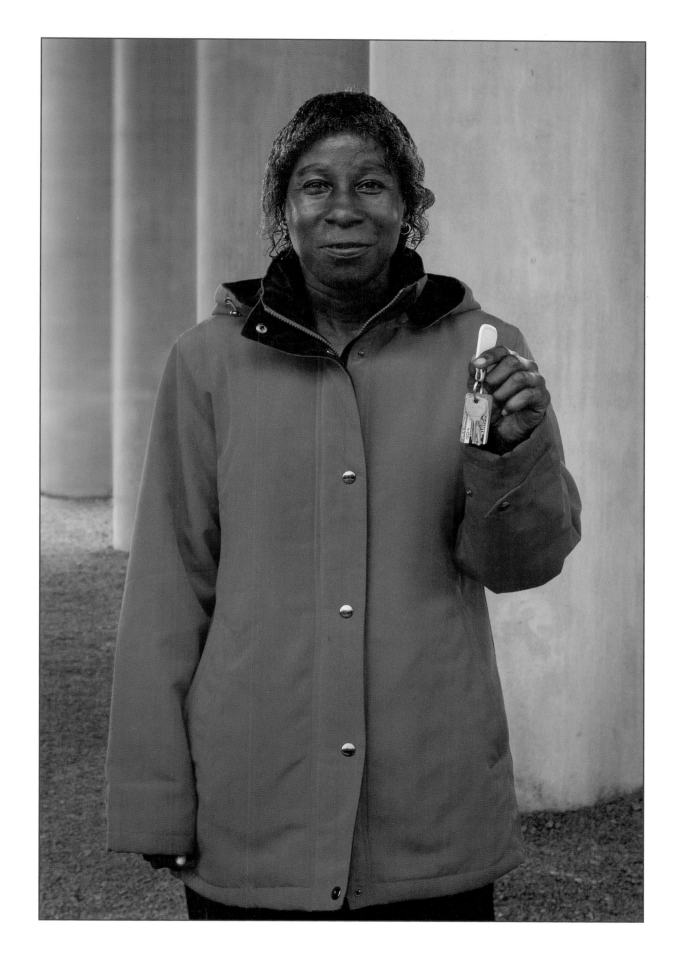

Tindall Herndon

Vietnam Veteran
Homeless
2008

"I keep my hat. I'm a Vietnam Vet and I wear it to remember my brothers that died over there. It's a part of me. I wear it all the time. I wear it every day."

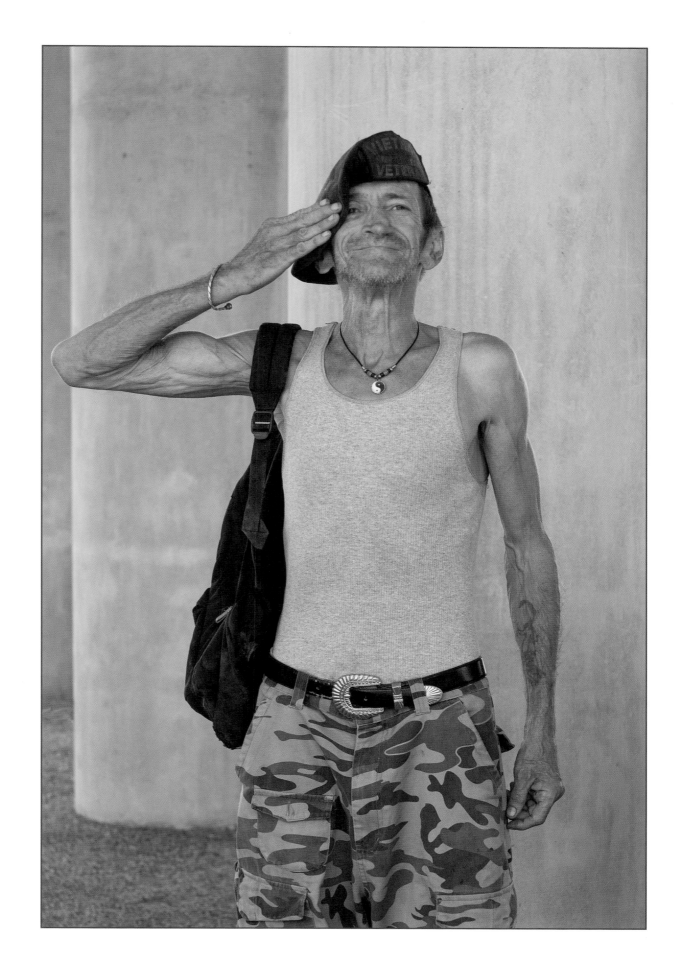

Christine McCutchen

Unemployed and looking for work
2008

"I have pictures and clothes and stuff. My cousin threw all my things and clothes in the trash; I had to buy all that stuff new. You can lose all that stuff, DVD player, VCR, but you can never lose your pictures, you can never replace them. These are of my little girl, four years old. She doesn't live with me."

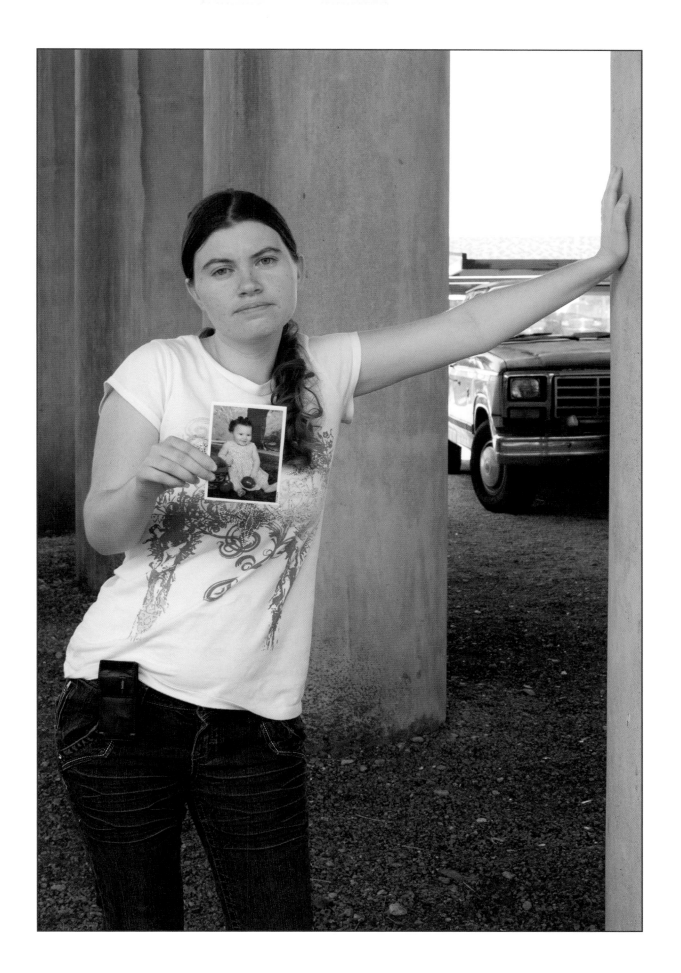

Raymond Dotson

Disabled
2008

"This is a sentimental jar to me. This is something I value a lot. When I moved I lost everything but this. Everywhere I go I take it with me. All of this is found: cell phones, jewelry, tape measure. I just cherish it. I find something, I keep it."

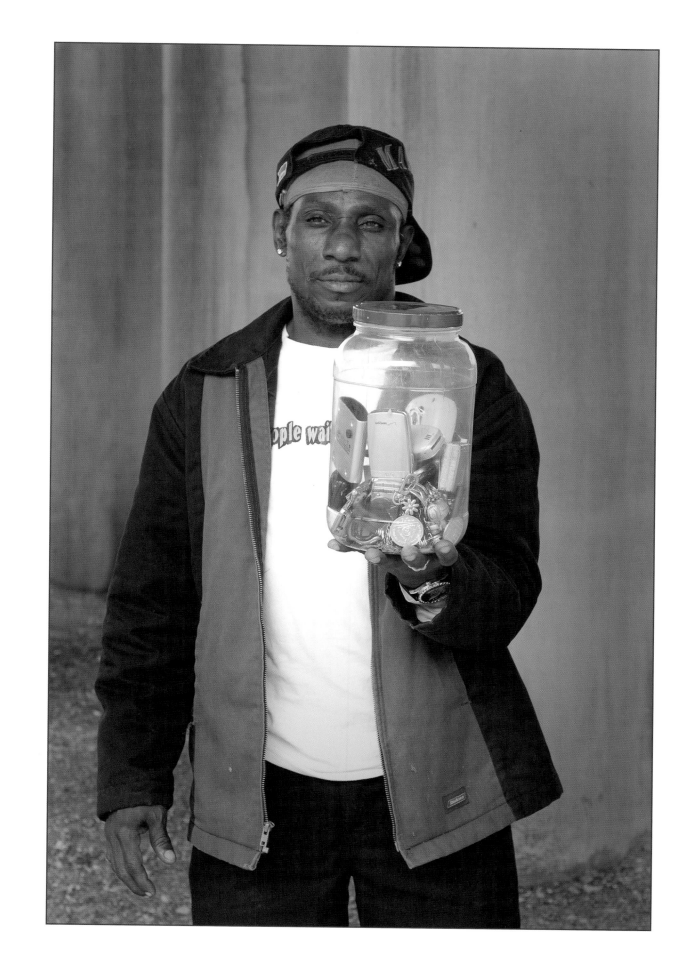

Jarred "Wolf" Jones

Tattoo Artist
Homeless
2009

"It's who it came from and what it meant to be given such a thing. It came from my teacher who earned it from his teacher. It's an irreplaceable thing. It's been carried by very important people in my world who have shared their life so I can better my life."

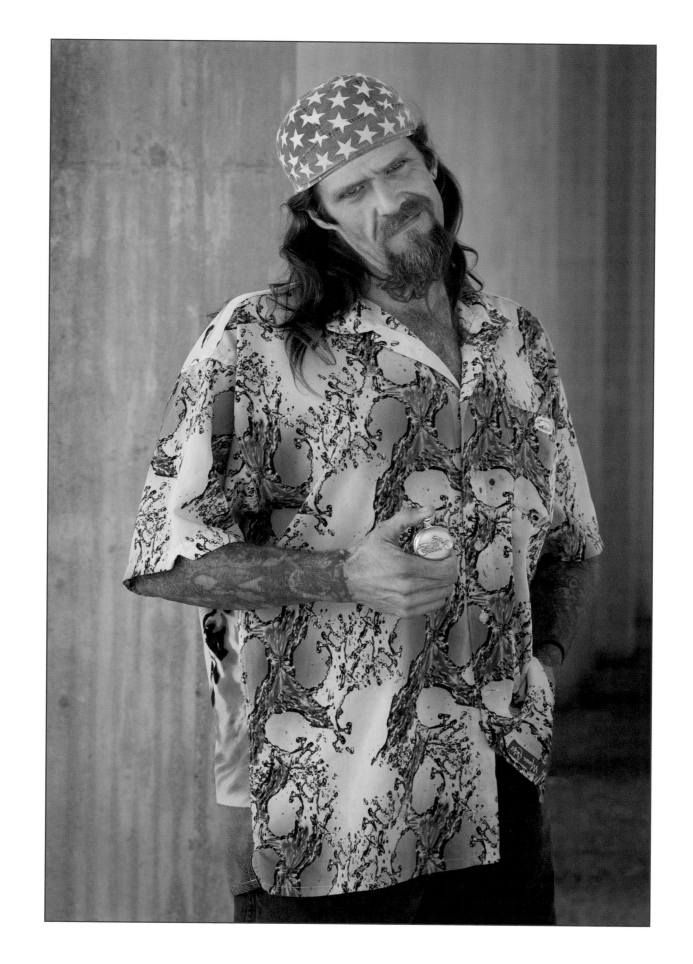

Gail Wilson

Former Food Service Worker, WISD
Disabled
2008

"I kept my junior high diploma and report card and my high
school diploma and report card and the business card from
the college where I went to. They just said that when you go
to get a job you need a diploma so I kept them. Everywhere
I moved I kept them with me but I never showed them on
a job interview. This is the first time I took them out in 32
years!"

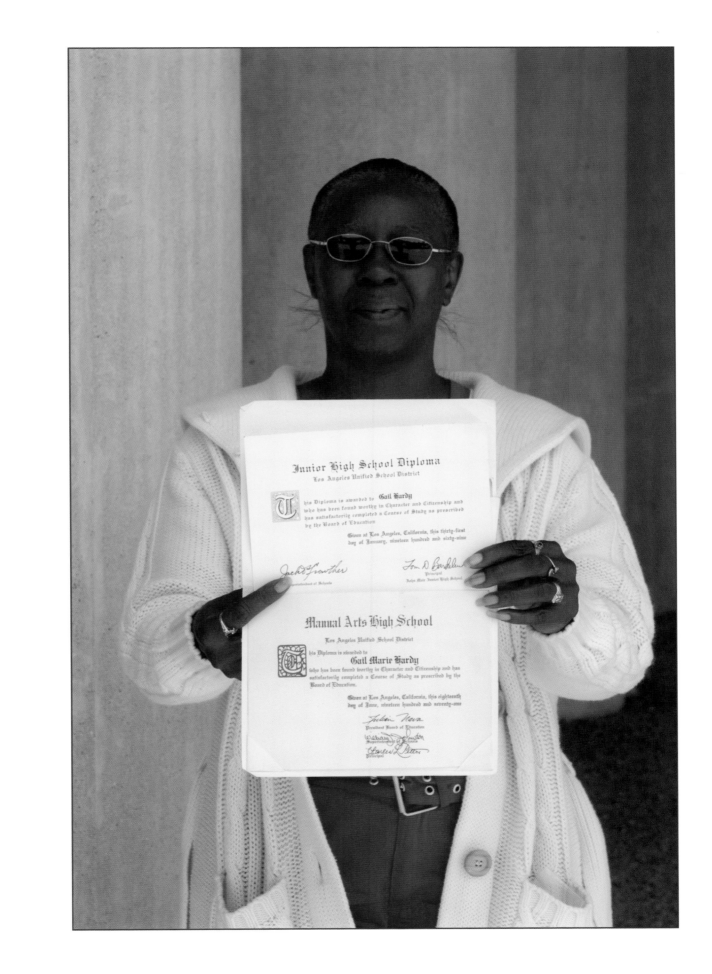

Jarrell McCasland

Homeless
2008

"I've been on the streets but now I have a place. This is my old *"Stand Down Card"* — that's my life. I just re-fixed it. Over there at the YMCA you use it to get free haircuts and medical care. Over there they help you out."

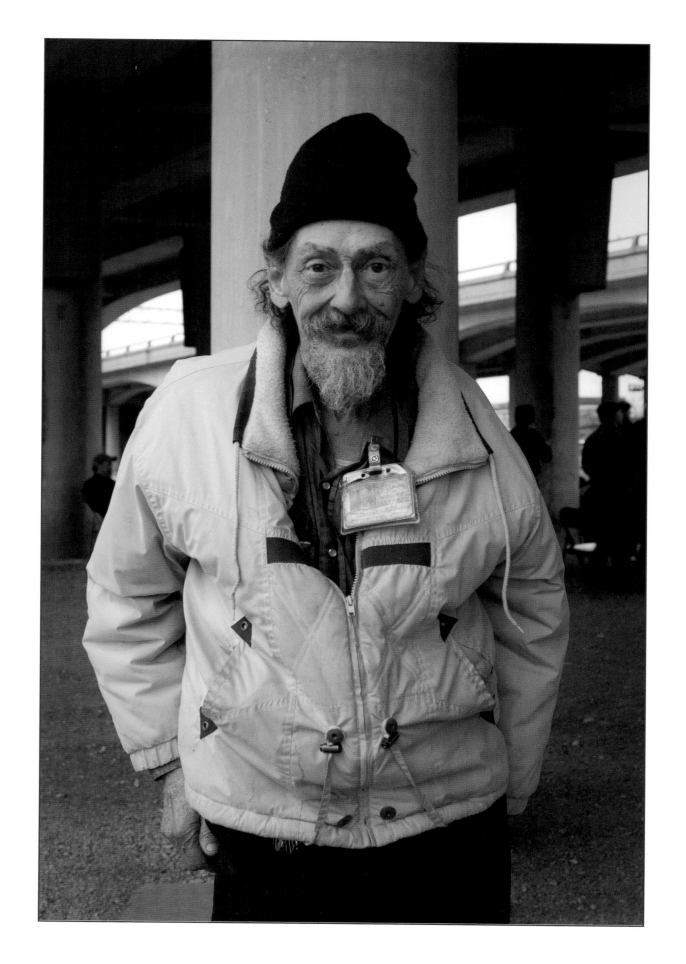

Joanette Burke

Home Health Care Worker
Disabled
2008

"I don't like to throw my hair away. My nerves are so bad it started coming out and every time I combed it I'd take it and put it in a bag. Now it's growing back but I still keep it in a bag when it comes out. And now I pull it straight and weave it, braid it. It's getting long. See?"

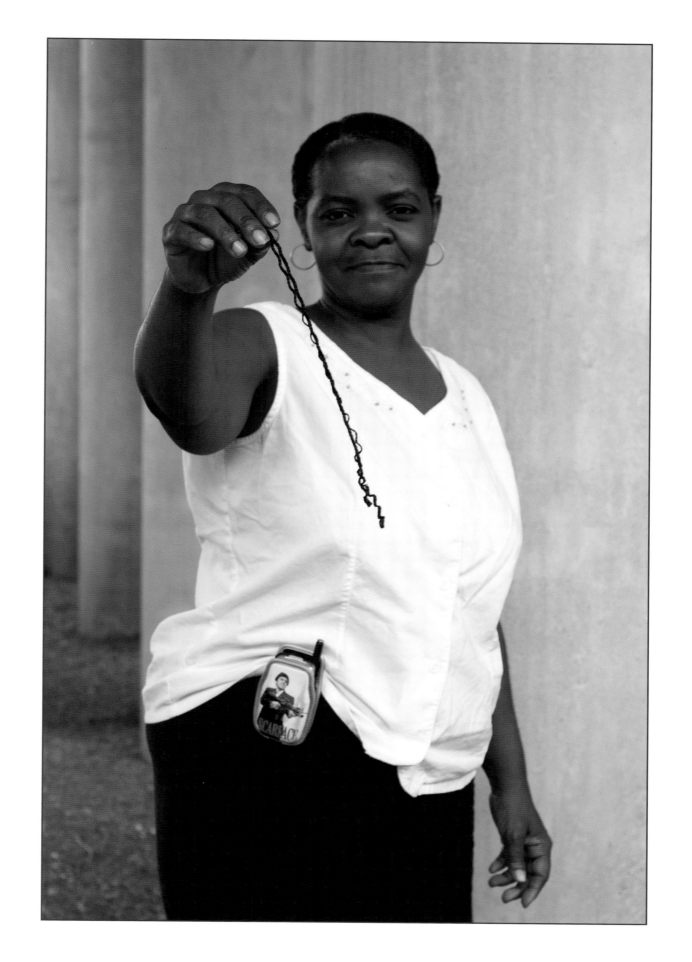

Gary King

Former Computer Technician
Disabled
2008 *d. 2009*

"Over the last eight years, these two plates are the only family memories I have left. Only by the grace of God have I been able to hang on to them. They're hand painted.

I believe that both of these plates were done by my dad's mom. The one I especially wanted to hang on to was especially done for me. It was stolen when the storage unit got busted into."

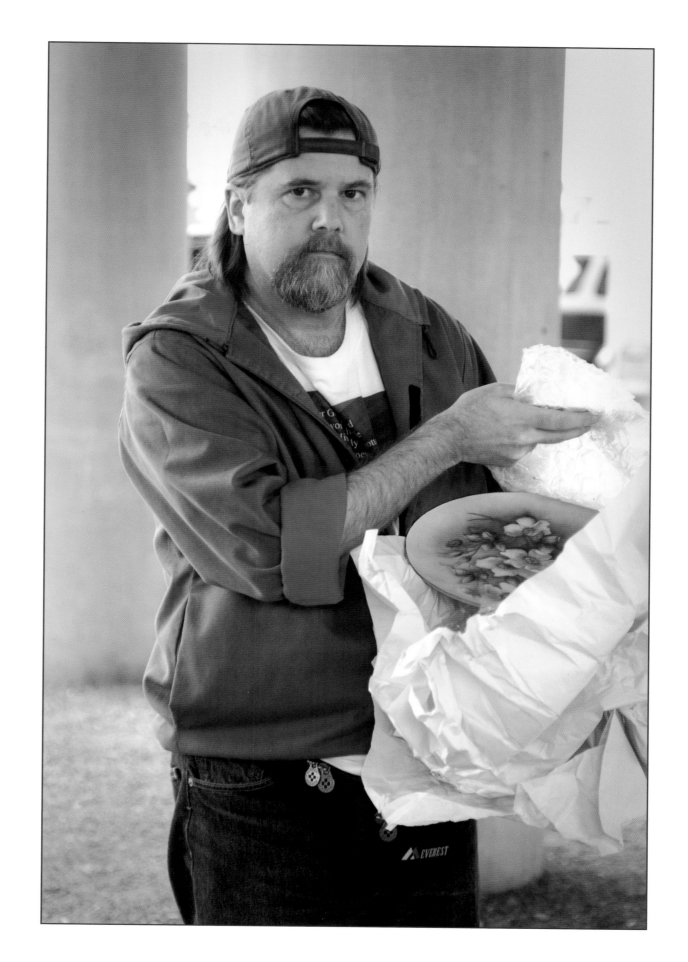

Janie Dunlap

Retired Cosmetologist
Disabled
2008

"That's my great-grandmother's antique (7UP bottle). It was passed down to Mary Deil to Gussie Johnson to the great-great-granddaughter, me.

I moved it everywhere I went."

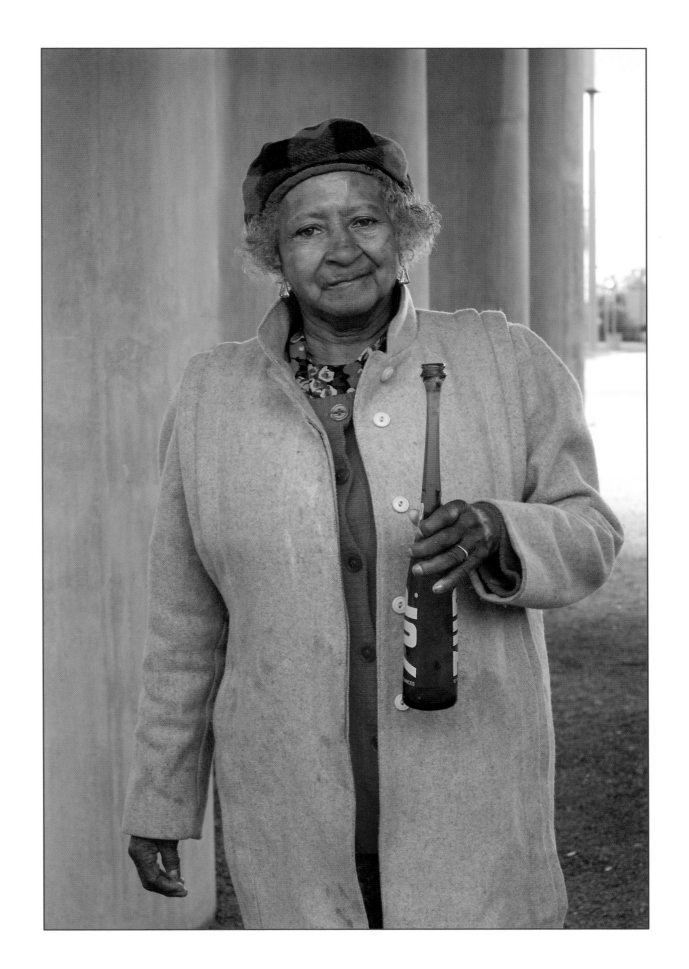

Virgil Lee Bell, Jr.

Apostle
2008

"I played this washboard for twenty years. I saw one young lady in church, she was a Spanish young lady, playing the washboard. And then I told her I could play that, I could play that, let me see that! As soon as she let me see it and play it, God just blessed me to pick it up and start playing it instantly. I was in another church and I saw another young lady and she had something like a fish, it was a washboard but it looked like a fish, with scales, and it was a washboard. And she played it. And I played it, too. I sing gospel songs with this."

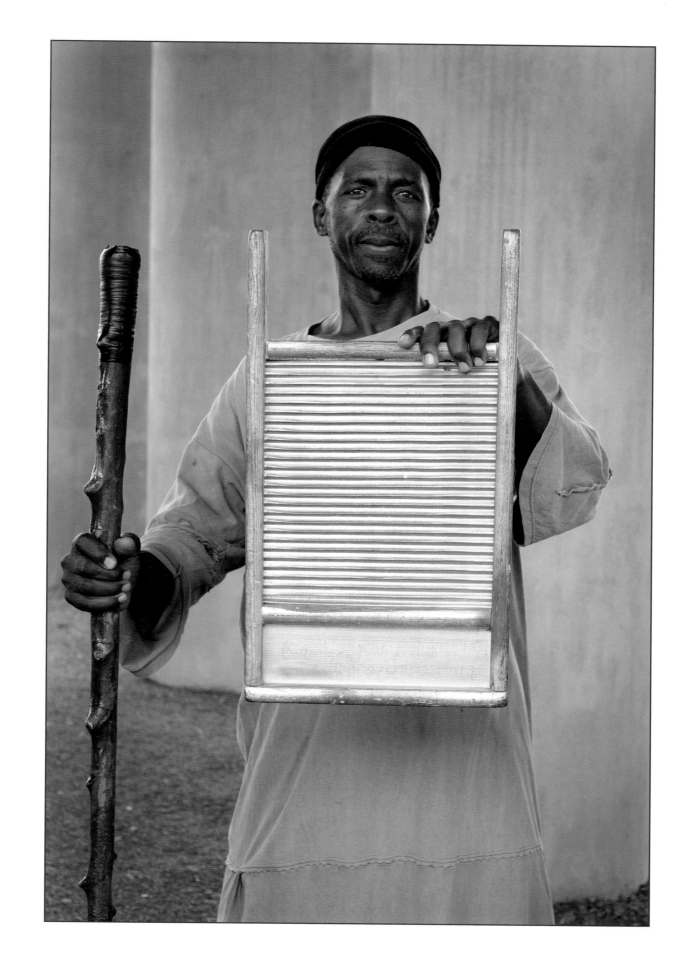

Patricia Anne Ragsdill/Martin

Truck Driver, Musician, Beautician, Mother, Grandmother of 6,
Forklift Driver, Cashier for 30 years, Sign Language Teacher,
State Champ in Tennis for 2 years, and Former Felon and Addict
2008

"I'm here to show that God does work miracles; that ex-cons
and pit bulls aren't dangerous. Her name is Indy and she
represents the female dogs. This is my pride and joy. She
comes from a big breed I started raising them in 1975.
I went to prison in 2001. I cashed out 5-5-04. I was a drug
addict and found God in prison. I was in 3 of them: Dallas,
Gatesville and Marlin.

The beaded necklace represents the 'Oklahoma.' My mother
came from Hugo, Oklahoma and she's got Indian in her. My
dad is from Bogota, TX — makes me an OK Texan!"

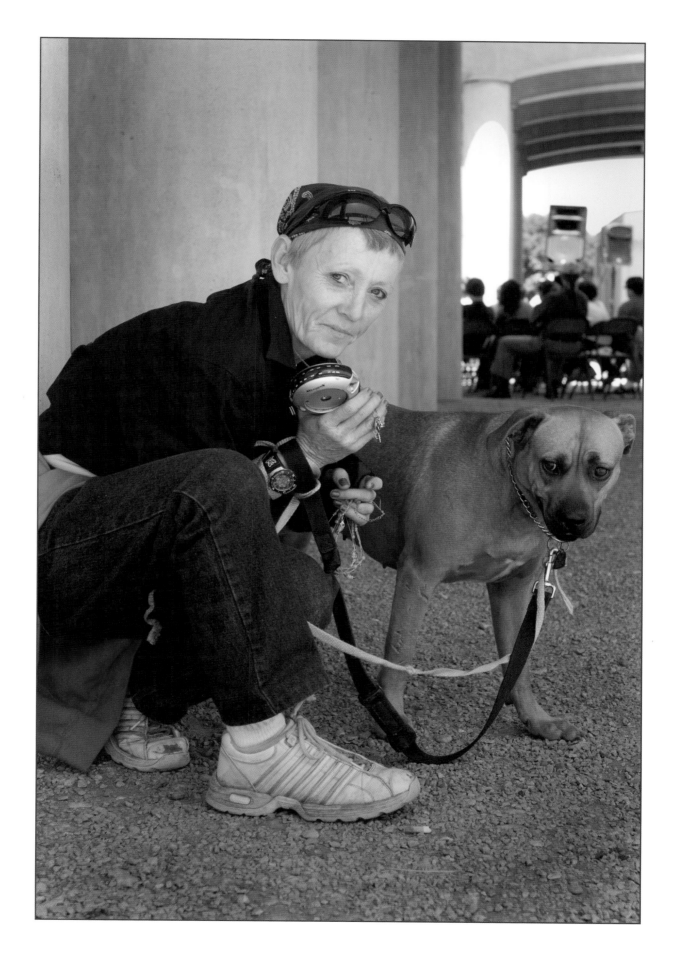

Fred Lee Gosten, Jr.

Former Children's Counselor
Recovering Addict and Thief
2008

"I've had it for years. And you can tell I've had it a long time because the print is fading. I put some clear tape over it. I think it's the only one I've ever had after graduating school. I had that. It made it through jail and made it through the streets, I've had it for years. It has been able to identify who I am. If I didn't have no ID, I had that."

Charles Rose

Former Carpenter
Homeless
2008

"I was a librarian, I read more books than you can fit under the bridge. I like chess and backgammon, they're intelligent games. I keep cards too and I don't play traditional games, I play pinochle. I play with another homeless person who's probably as well rounded as I am.

What it is, I'm 51 years old, I have four college degrees and I've been a carpenter for thirty years. I don't know, I just got to a point where I couldn't find anyone worth working for.

This life becomes addicting because we're our own people. We got no boss hollering at us and we go where we want to go and we do what we want to do. All I have to do is eat and find a place to sleep. I got my cans and copper wire. Granted, it's not the ideal life.

If someone gave me a million dollars I'd open another home for the homeless. I helped build My Brother's Keeper (Waco homeless shelter for men) but never spent a night there.

With all my degrees, even though I don't use them, it's nice to have the knowledge."

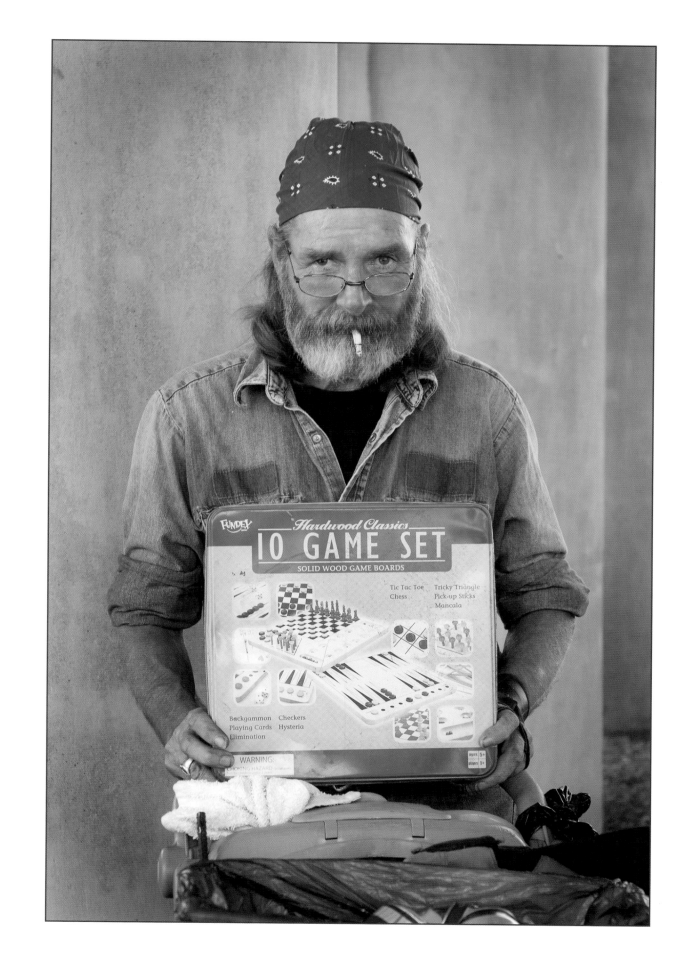

Larry May

VA Pension – Leukemia Patient
2009

"This is *Strong's Exhaustive Concordance of the Bible* and it has a Hebrew and Greek lexicon in the back. I've had this book since probably 1995. I don't know how anybody could grow without this book. This book was given to me by a brother in payment of a debt. Sometimes in the King James the words don't mean what they think they mean so I check everything. I keep it."

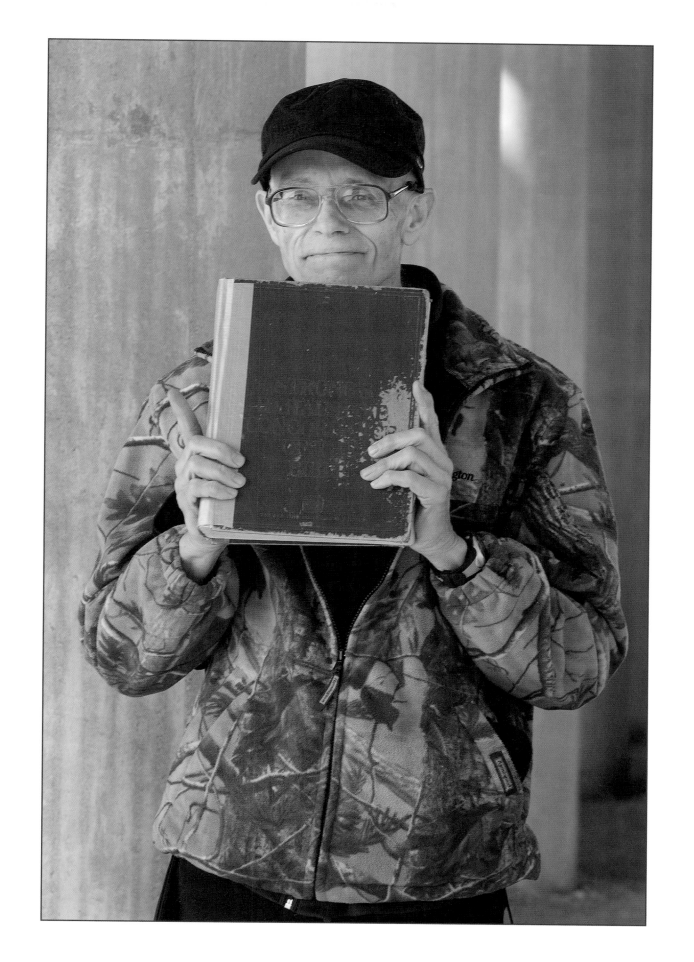

Ernest "Fat Jack" Taylor

Unemployed
2008

"It's my birthday and this is my present money."

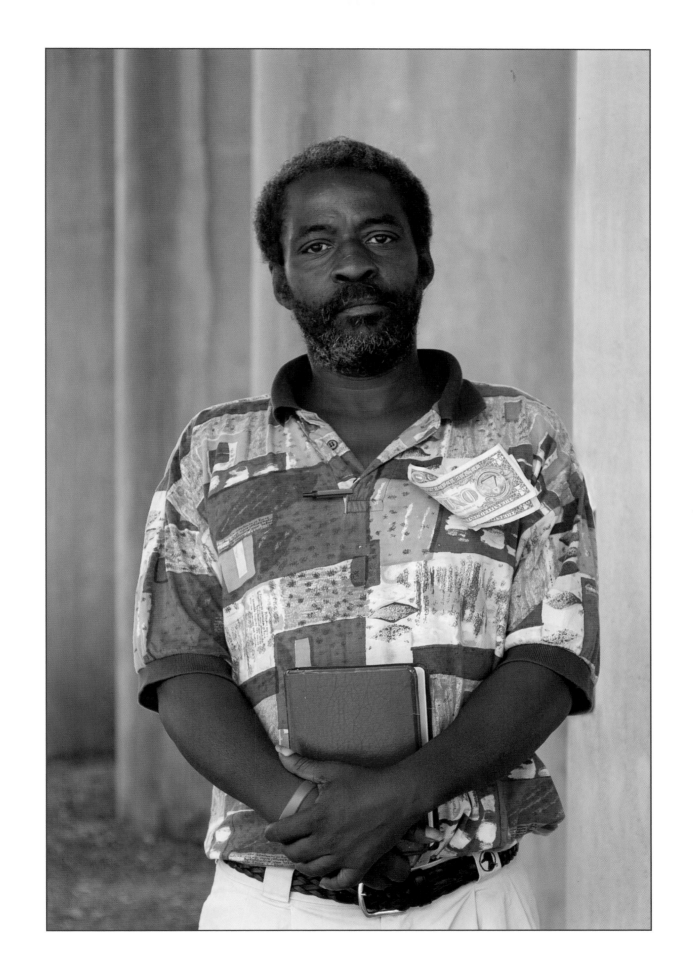

Wilhelmina Susan Norris (Welch)

Labor Ready
Homeless
2009

"It's my dad's watch. He's had it for years. He's deceased;
it'll be a week Thursday he passed away. Dad told me, he
always said be strong. That's the trade he gave me. I'm
going to keep this for sentimental value."

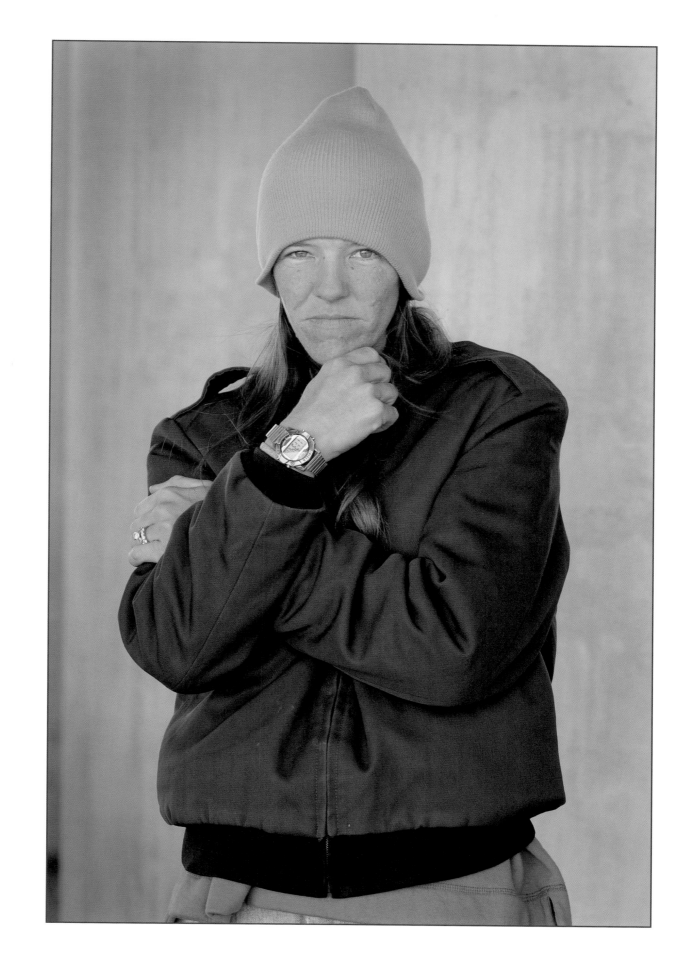

Brian Ross

Parks and Recreation Employee & Recently Married
Formerly Homeless
2008

"I bought this hat in San Antonio in the Burlington Coat Factory. I was working in Labor Ready. I liked the hat and I bought it. When I find something I like, it catches my eye, I do what I have to do to get it. I worked hard and I bought the hat. And I always wore it."

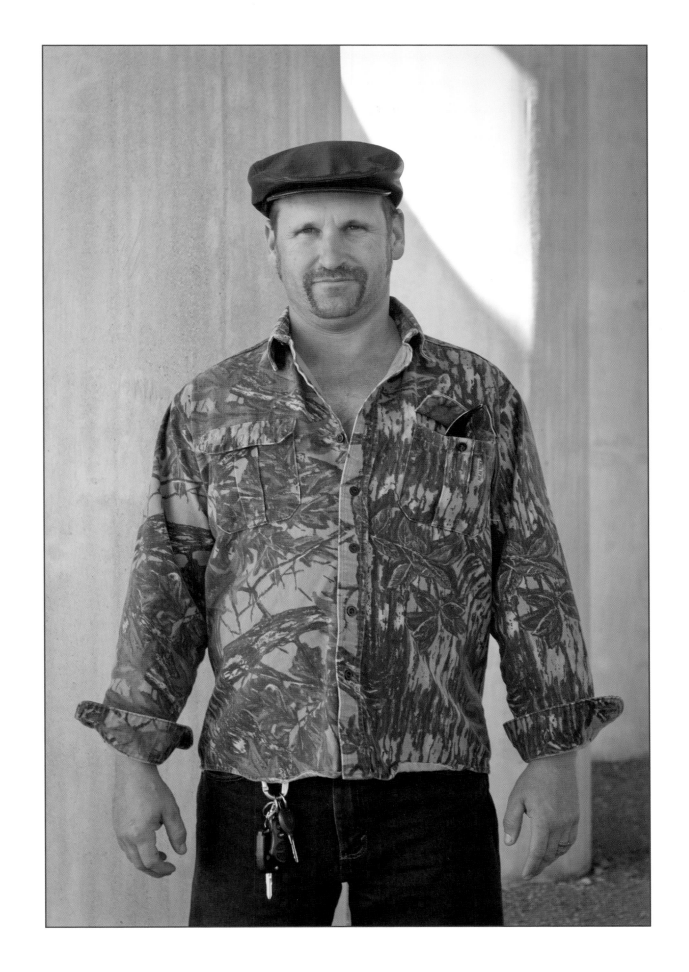

James Royce Smith

Disabled
2008

"This is a picture of me and my wife, this is what I keep. I lost her about a year ago. She was at Green Manor. I always keep this. I'll keep it 'til something happens."

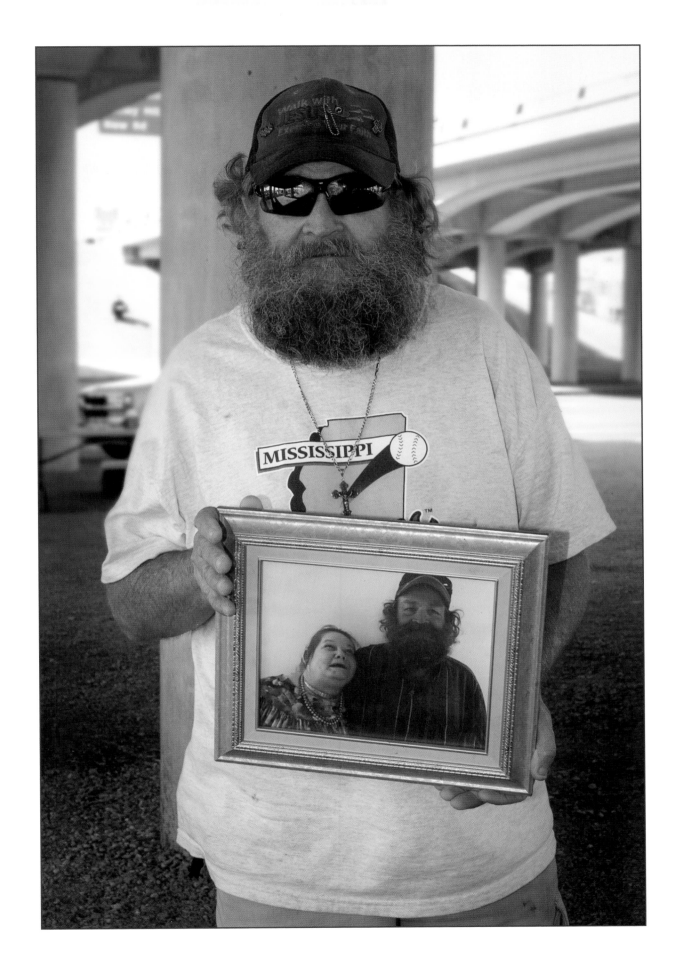

Angelia Patterson

Unemployed
2008

"I keep nothing; I just start over. I been to Fort Worth going
on a year and then I moved down here been a month
already. I got a new house last week. I just got everything
different. I feel happy to have the new. If I lose that material
stuff it's OK."

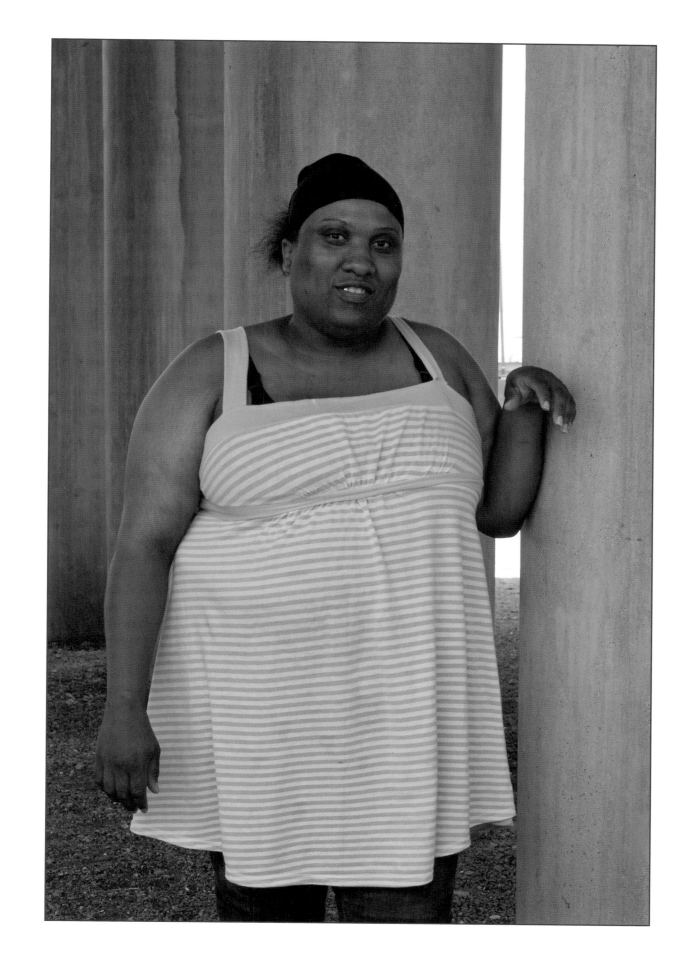

Favian Vera

Former Carpenter
Recovering Addict
2008

"This tattoo is what I've got from before I got here. I had a truck and I traded it for drugs and everything I owned was in it.

I got this tattoo when I was 19 in prison. The name on it I didn't get 'til I was 38. I didn't meet my wife 'til 20 years after I got the tattoo and it looks just like her. She's French and Portuguese.

It was made with an electric shaver, you take the little motor that's inside the shaver and attach it to a spoon and take a pen apart and attach that to the spoon, and you can make a tattoo with it. It's pretty neat what you can do.

I still love my wife, we're separated and probably won't get back together, there's a long story about that — but this place (Manna House) is like a womb for a new birth, a new life.

I started doing drugs when I was 6 years old and by the time I was 15, I was a full-fledged addict. I had a lot of older brothers."

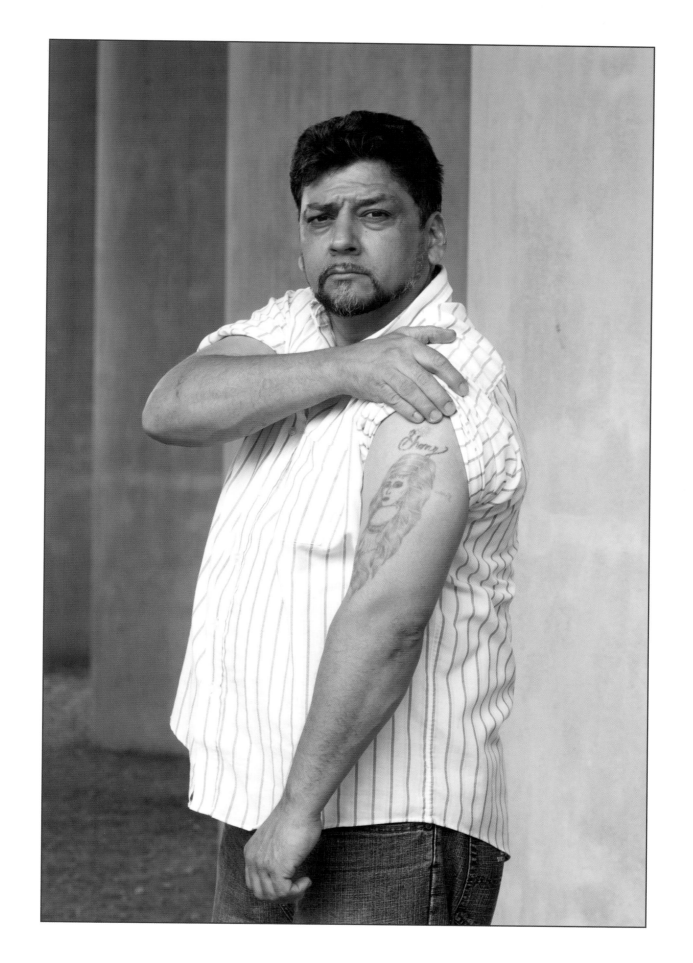

Kenneth Kucker, WPM

Waco Peppermint Man
2007

"I'll have some of them as I'm going to my grave. They make life sweeter. It ain't got nothing to do with your breath, that's just another one of those lies that America tells you, like clothes. You know I'm always the same person no matter what I'm wearing. I always have the spirit and his work with me."

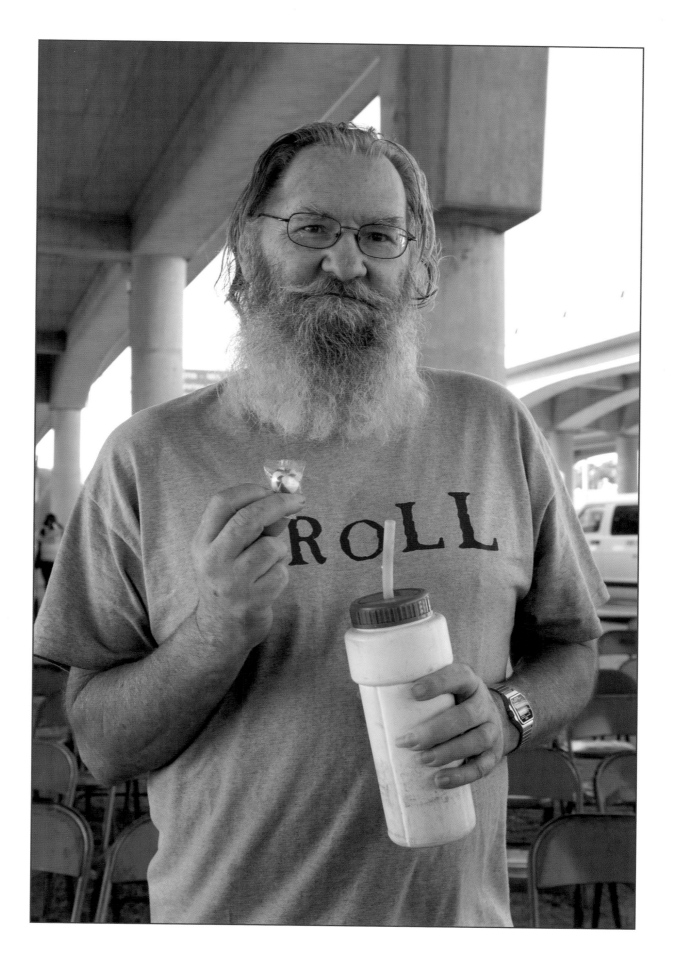

Janie Cooper

Substitute Teacher, Mom of Six, Formerly Restaurant Worker,
Restaurant Manager, Hairdresser, Singer, Organic Farmer and
Produce Sales, Beekeeper, Vending Machine Business Owner,
Chef, Tutor and Homeless
2008

"I save these letters from my friend, Michael R. Smith, who
went to prison in 1987. I didn't bring all of them; I brought 10.
I keep them in one of my crates from when I was homeless.

When I was homeless, I had a crate for each of us and a
crate of toys for the kids. I had a brand new car so I couldn't
get services so the kids and me lived out of the car for 6
weeks. We moved 17 times in 9 years but I wrote him at
least once a week for 10 years, usually it was 3 or 4 times
a week. I met Michael in junior high school and we were in
theater together from the 7th grade through senior year. He
played guitar and I sang.

We did a lot of the same things as young people. He got
caught up. I got out."

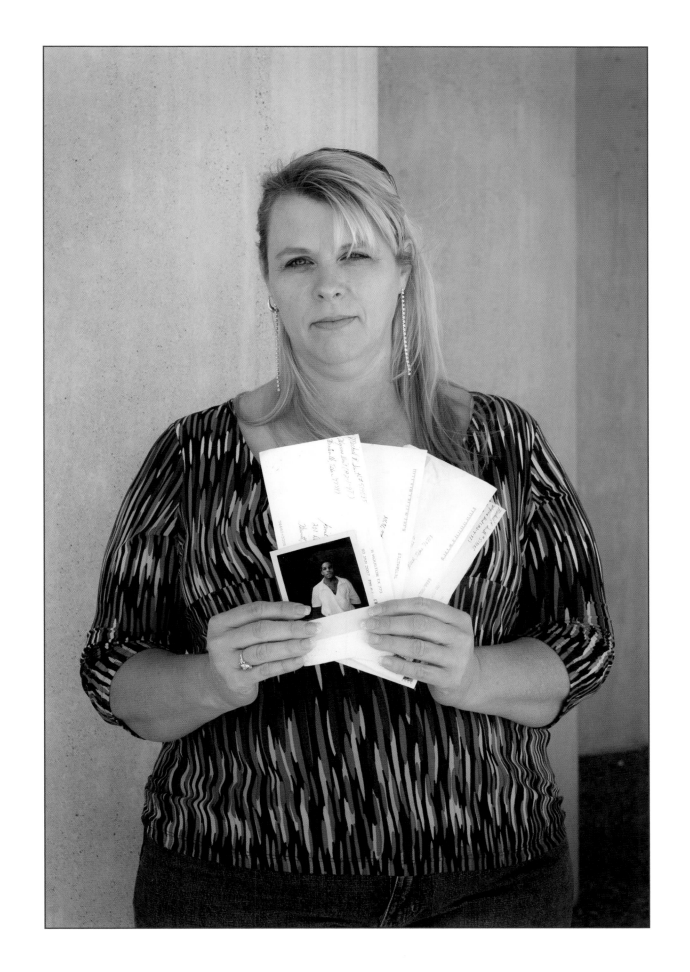

Nick Fox

Former Inmate
2008

"These tattoos, they have meaning. I put them on at one of the low points of my life when I was in county jail. I had really messed up my life; I was in a room full of people and found myself all alone.

I made the ink by burning some hair grease and it made soot and I put it in a cap with soap and water and used a staple to put it in my skin. I put them on my hands so I can always know where I come from and where I'm at.

One is my son, my oldest boy, his name: Marcus Fox. The reason that I got this one was that I always needed to know that there was someone out there that would always love me.

And this one (right hand) was to remind me that there would always be people out there that would have that hate for me. This one says: 'Hate me now, hate me later.'

All my tattoos have deep personal meaning to me."

Kay Bell

Middle School Teacher
2008

"I keep a lot of material because I like to sew. One day God just showed me how to sew without a pattern. I started cutting out material. I made this dress, which means 'The Power of God.'

Now I make a lot of dresses and every one I make God always tells me what each one means. Another means 'I Will Praise God,' 'I Will Dance with God,' and another, 'I Will Rejoice with God.'"

Teri Lyn Hughes

Homeless
2008

"Basically, in the practical sense, you need water to survive and a backpack to carry other survival — or even sentimental — items to survive on the road and on the street.

I'm so careful to keep water with me. I was on the way back to Beaumont where I have a tent. I forgot to fill up and a ride dropped me about 40 miles outside of Van Horn, on I-10, and I ran out of water that night. So I woke up thirsty in west Texas and it was 85 by noon.

It was completely deserted and no one would stop. Just myself and my backpack in the hot sun. No water. In west Texas. I was getting sick to my stomach and I prayed to God the Father to send someone with a kind heart who would give me a ride. When I finished I was tired and sick and I got up and started to walk again and I noticed a pile of trash and it was someone who had cleaned out their car.

There's no way to find water in west Texas in a hot afternoon. I walked by the trash and a voice told me to go back. Go back and look a second time. It was an imperative.

Under all the trash was a full bottle. It was a full gallon jug of distilled water, never opened. I drank, I filled and I drank and filled it again. Ten minutes later I got a ride. He loves to strut his stuff.

My tattoo says Yehovah; it's the outward marking of the spiritual."

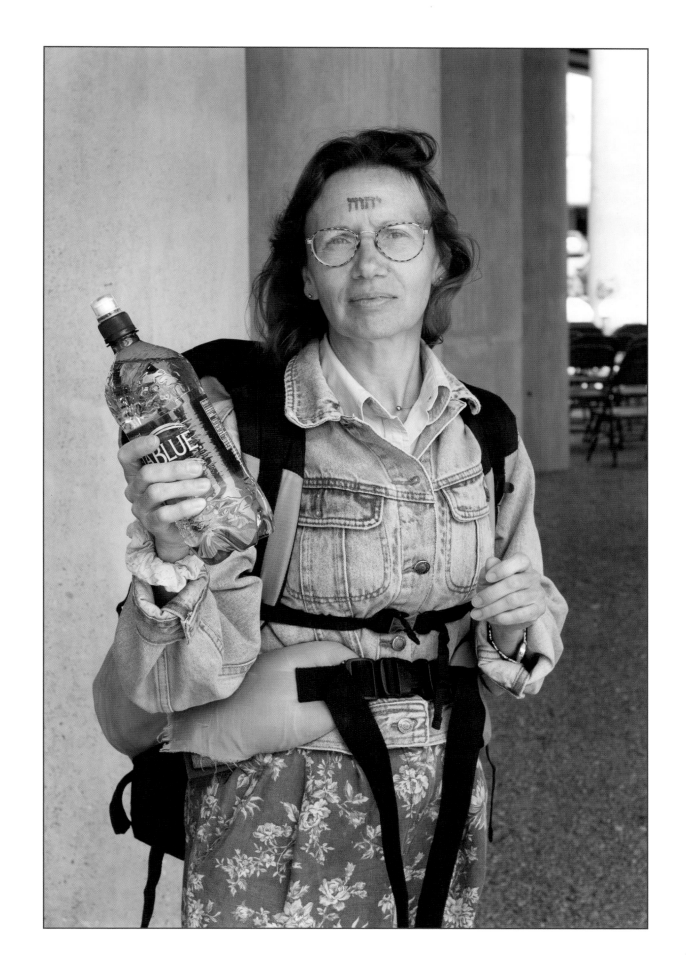

Johnny Dwayne Staten

Former Marine & Air Traffic Controller
SSDI
2009

"That's the most special because you keep what you have by giving it away. It's a Black Tag from NA (Narcotics Anonymous), it's the highest award you can get. After two years clean you get a Black Tag. I keep wearing them out.

I've been clean for 15 years. You know what a clean addict is? A miracle!

God was real good to me, I stayed alive."

Key Tag: Clean & Serene for Multiple Years of Recovery

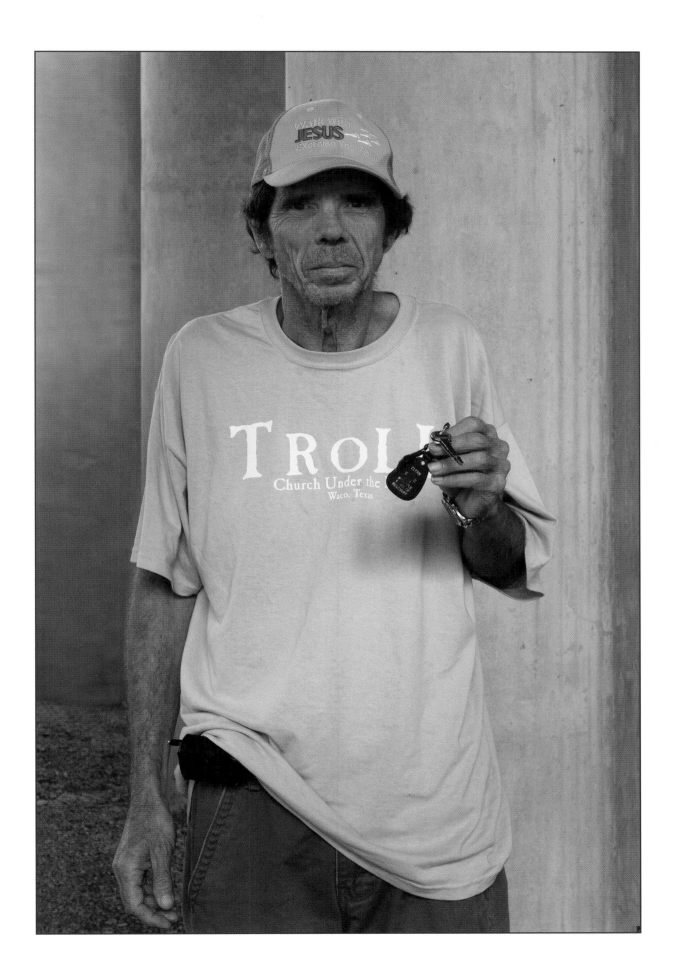

Marvin "Cowboy" Holcomb

Remodeler
Formerly Homeless
2008

"My hat was given to me by my mother-in-law. My hat represents who I am. Everybody calls me Cowboy. Without my hat I'm just like everyone else."

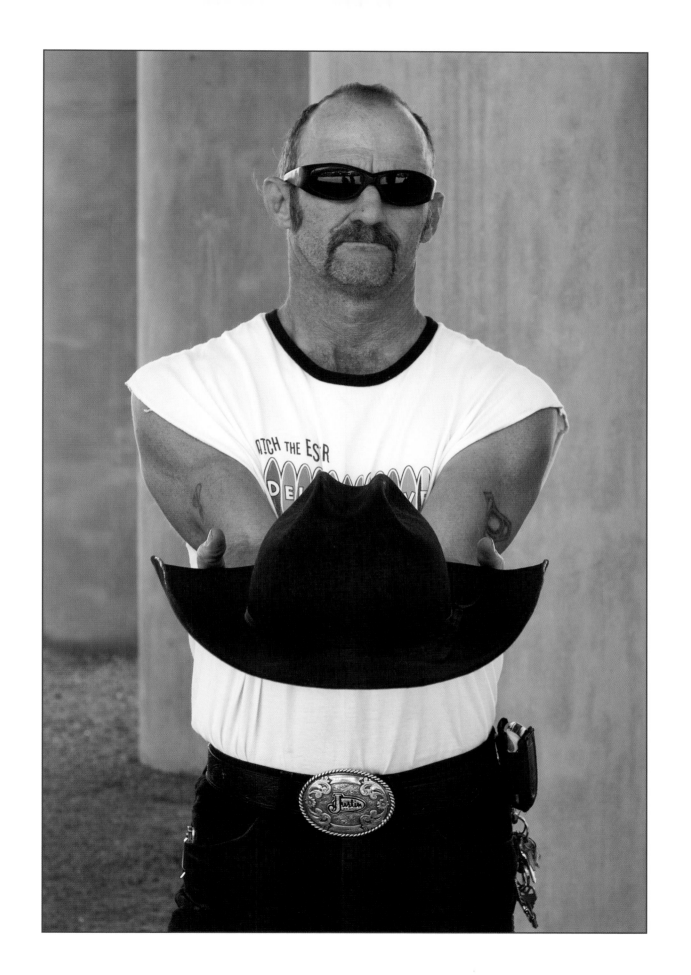

Jeffery Kerns

Plumber by Trade
Homeless
2009

"Of all the pennies I've collected I've kept this one wheat-back penny, 1945 — the year my mother was born. I love her and she went thru an aneurism surgery and that brought me closer to her and closer to the Lord. She had four children.

I am homeless; this is everything I own: my bed, pillow, trashcan, and my cooler. I have everything I need. I collect beer cans, that's the way I make my living.

I'm a plumber too; my grandpa taught me when I was just a young child.

That's how I spell Jeffery, that's the way my mamma gave it to me."

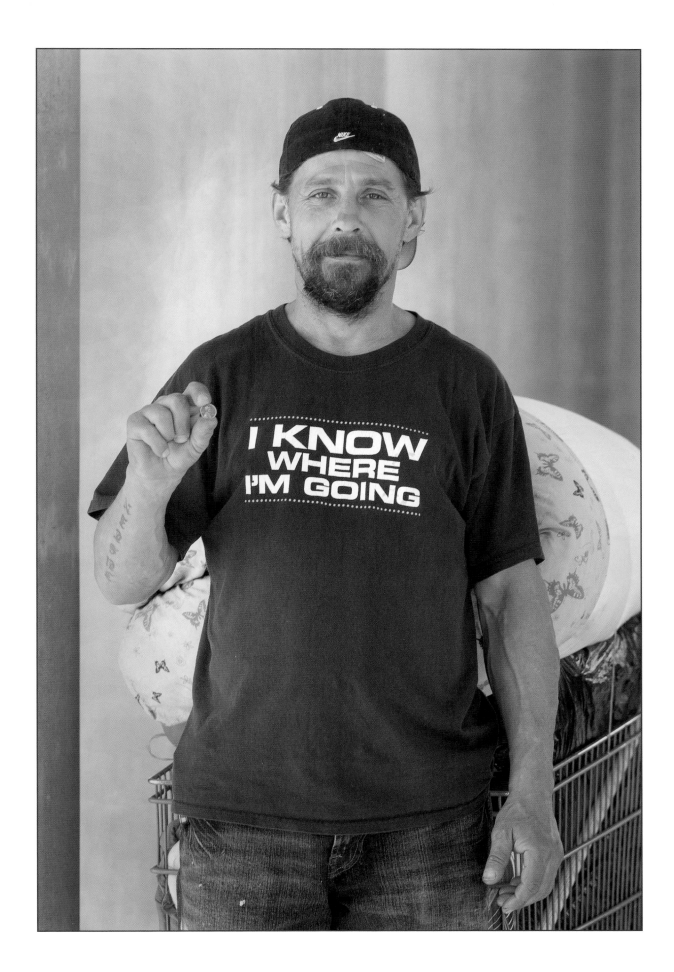

Fred Albreight

Carpenter
Homeless
2008

"I pick up stuffed animals all the time, I got a truck in here too. I found him, this little dog in a dumpster down in the projects in the South Side while I was pickin' up cans. The reason I picked it up is because whenever I see a little child I give it to him. That's why I collect them."

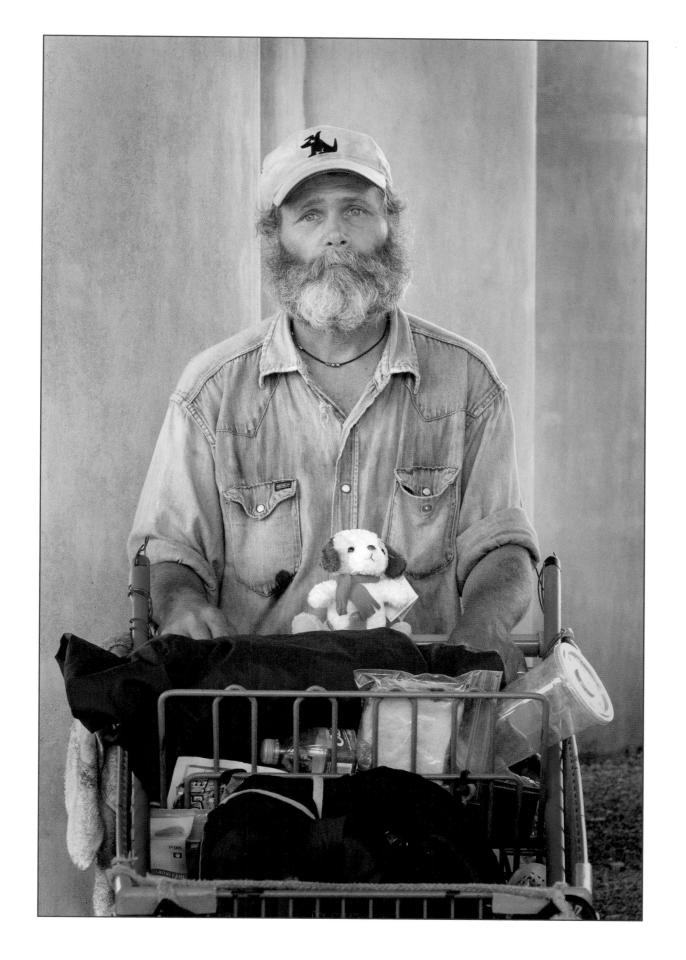

Patti Clark

Unemployed
Homeless
2008

"When my son was about three months old my guardian angel came to me. I was going through a real rough time and the angel gave me comfort to continue. I was having a major fight with my ex-husband and it comforted me to know that everything would be OK. Since then I've collected angels; I have lots of them now."

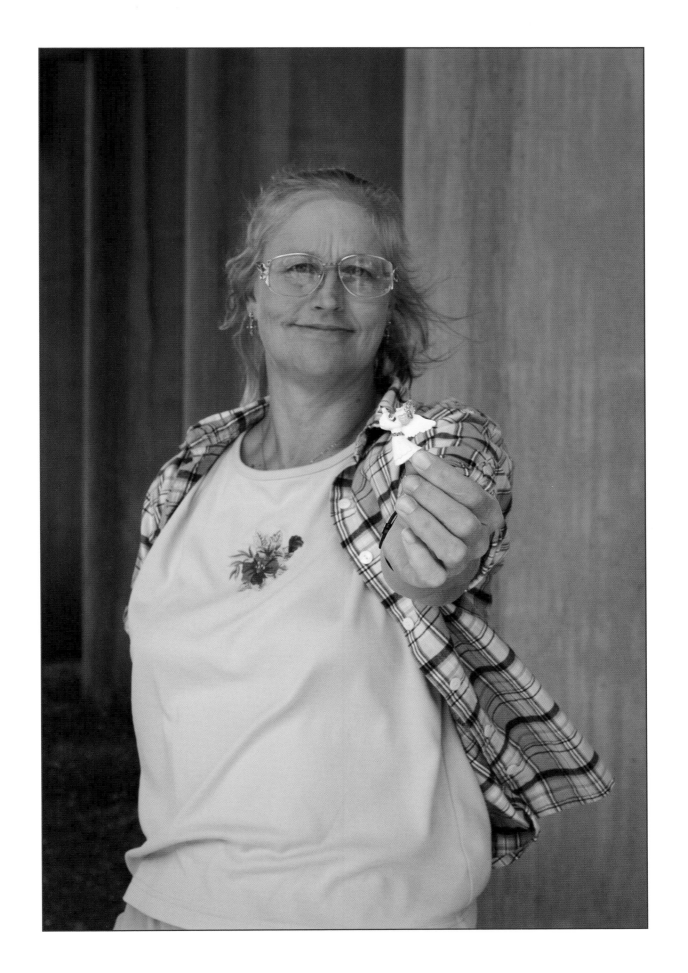

Cecil Jones, Jr.

Former Fast Food Cook
Homeless
2010

"I don't keep these, I make them and I give them away. It's something to pass the time while I wait. I just give them away."

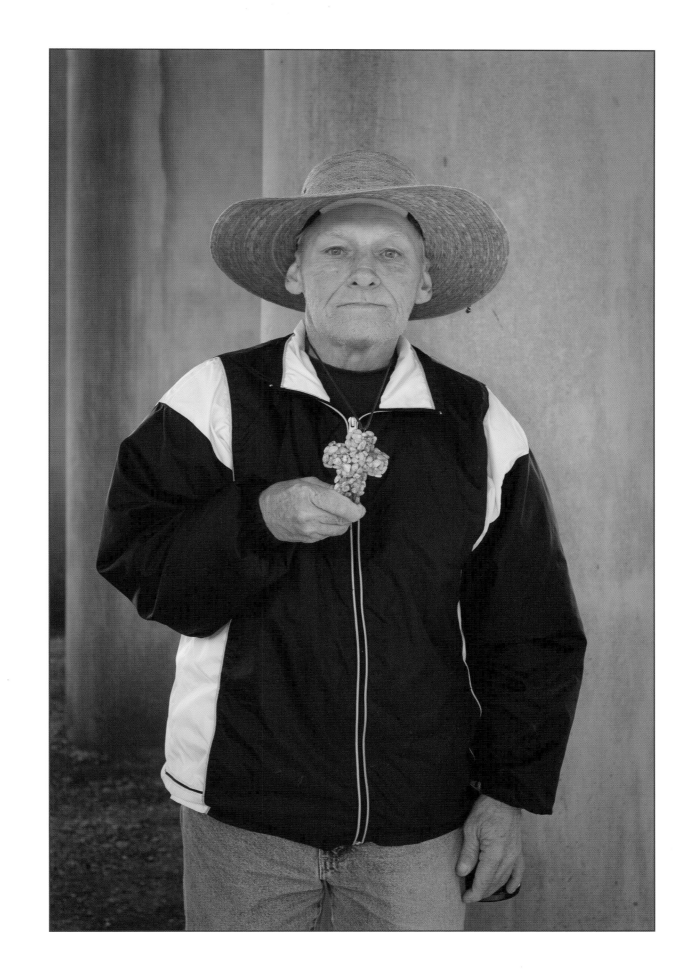

Rhonda Barnes

Student
2008

"I keep this because my dad gave it to me and he's been dead a year now. I have an empty hole in my heart but for some reason it feels like it fills it. It feels like his spirit is in it, it makes me feel close to him. He gave it to me in 2003. I'm going to keep it always."

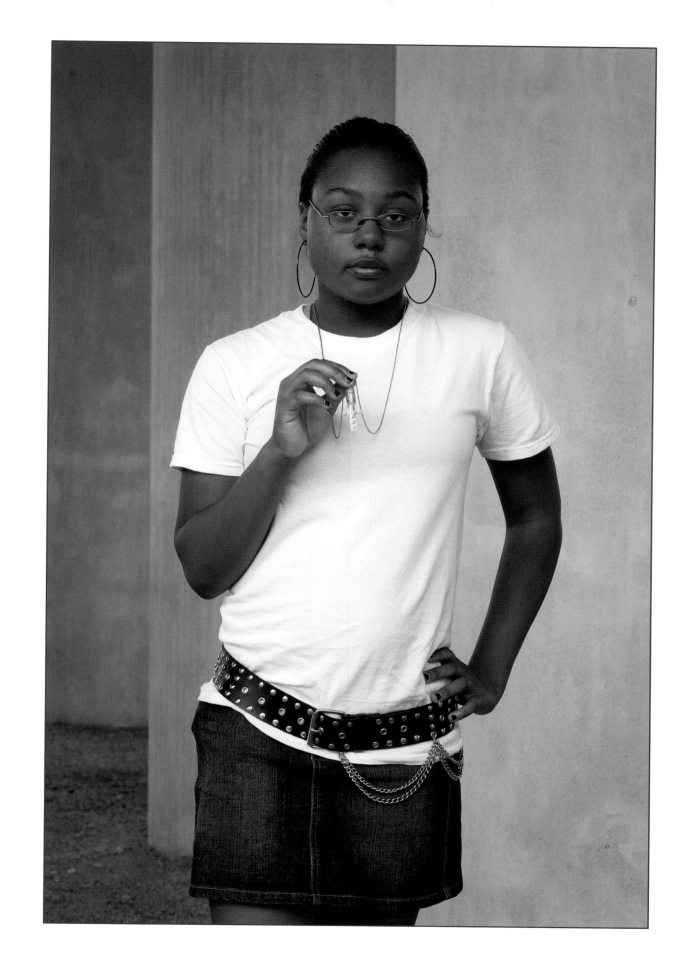

Robby Parrish

Homeless
2007

"I got that from a friend of mine who didn't have anything —
in the process that I gave him something to eat. He didn't
have any money at the time. I just kept it for that reason."

Later date:

"It got destroyed in the fire this month and I don't have it no
more. They burnt my tent. Right now I stay at My Brother's
Keeper. For right now. Now I don't have anything."

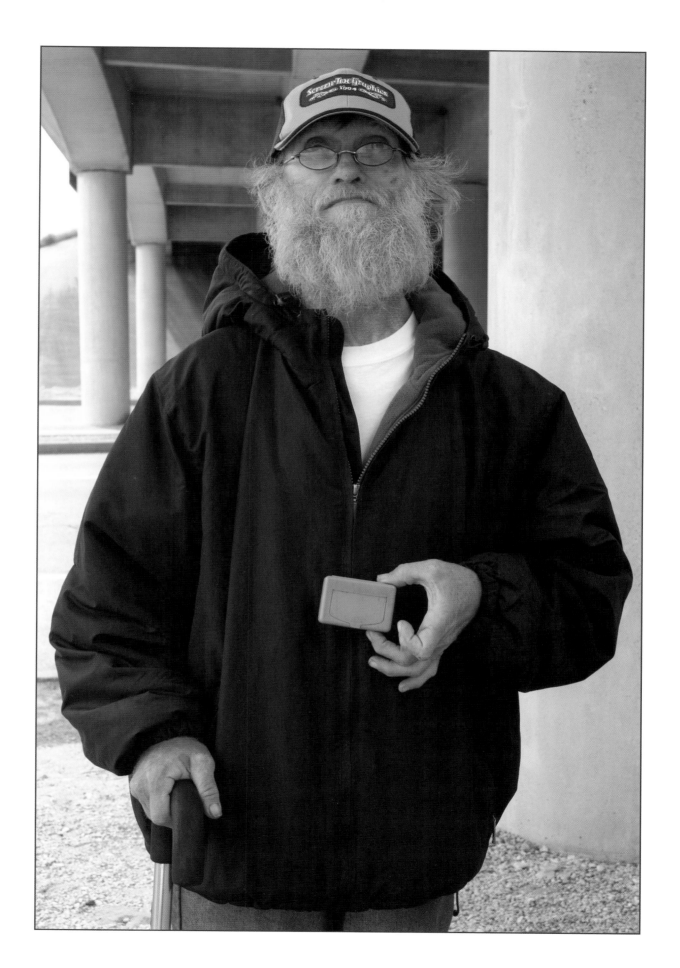

Gloria Vasquez

Quality Care Nursing Home Resident
Disabled
2008

"It brings happiness if you understand about flowers. I like the flowers because when the wind blows I can feel the fresh air and they smell so pretty.

You'll make a lot of money from that picture of me because a lot of people know me. And I know them."

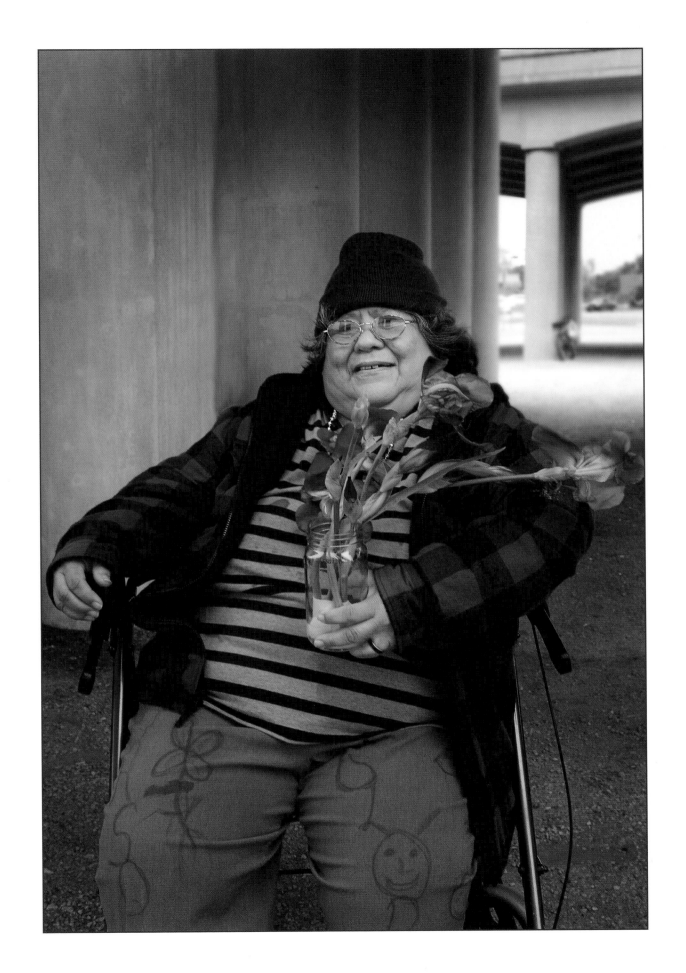

Billy Alexander Overstreet

Car Detailer
2008

"I graduated when I was 16. One reason I keep it is because I was 16 and my mother was 16 when she graduated and she went to college and I wanted to too. I keep this to remind me of her. She was a schoolteacher and we moved all around to where she taught. I only went 2 years to the integrated schools. Colmesneil, Texas, May 30, 1972. Deep east Texas."

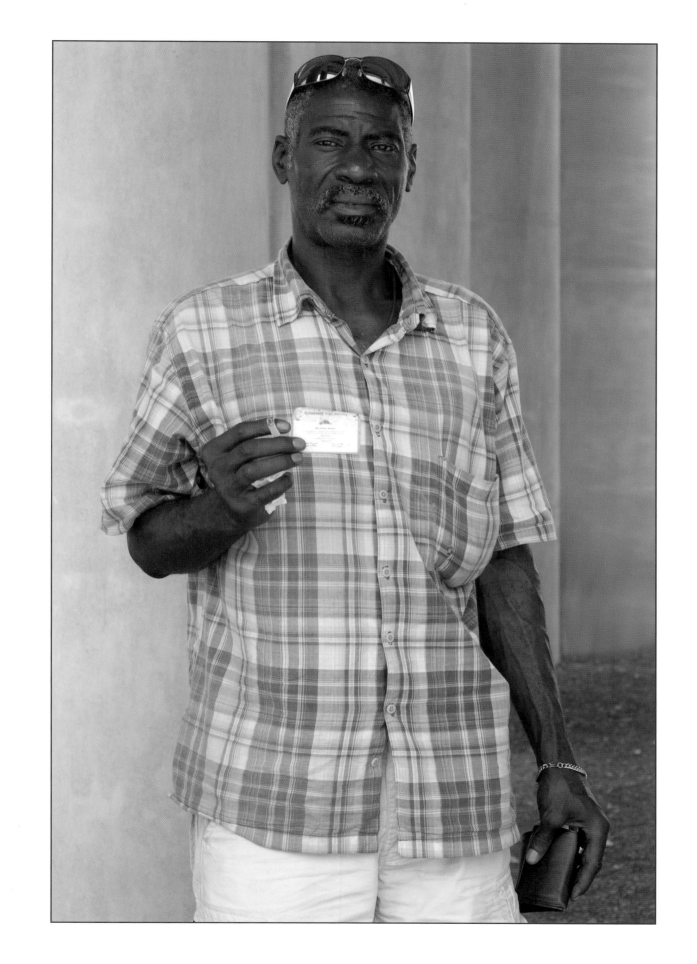

Rev. Brenda Bell

Security Service and Janitorial Landscaping
Candidate for Mayor of Waco, 2008
Self-employed since 1975
Formerly Homeless
2008

"4700 Fort Avenue #18. I've lived there 1 year as of April 13, 2008. I was living at the William Booth Apartments approximately 5 years. The reason I became homeless — the executive director asked me if I smoked marijuana and I said yes and she said, 'well, you can't stay here' and she made me leave. She made me leave for telling the truth.

They sold my stuff and I was arrested when I tried to get my stuff so I spent 60 days in the county prison. All I have is a brass lamp and I can't bring that. I have a crucifix; I'll bring that for the picture. That's all I have from before. I had beautiful furniture and things and they sold it all. I don't have any of it and it was beautiful stuff, you know?

For 90 days my SSI check went back to Kansas so I was living on the streets, at Brother's Keeper and at the Meyers Center. I'm from Chicago, I moved here in 2000."

Later:

"This is the crucifix I told you I keep. It's been blessed."

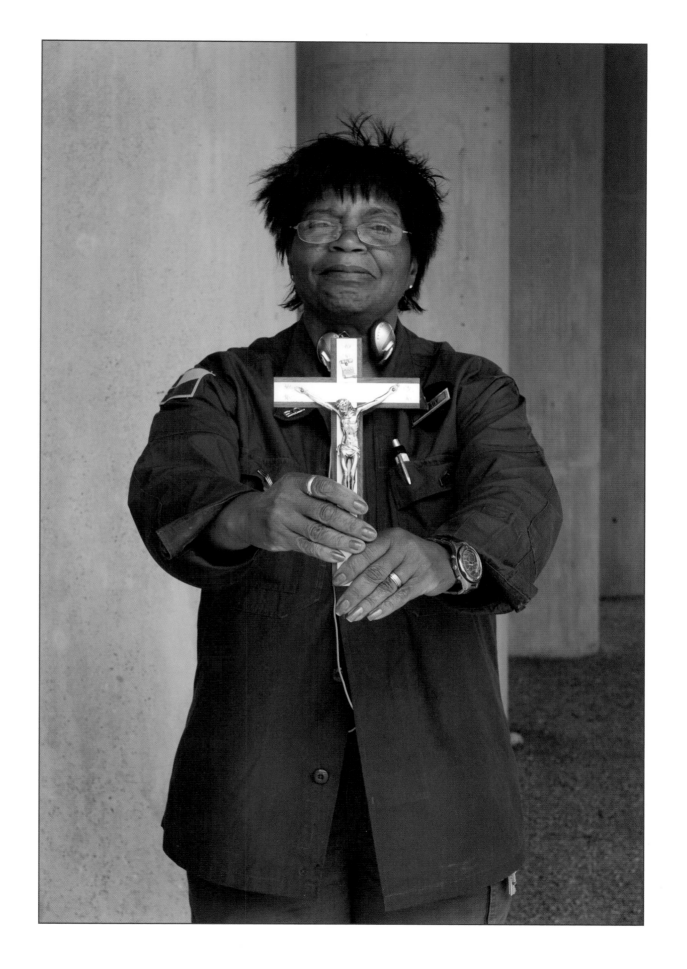

Jaymie Taylor

Singer
Formerly Homeless
2008

"This tambourine, I prayed for it and I got it. It means everything to me. I was at work and the boss was moving some stuff around that didn't sell at the garage sale and this tambourine had $3.00 on the box. I said, 'Is that for sale?' And he gave it to me. So now I'm making a joyful noise for the Lord!"

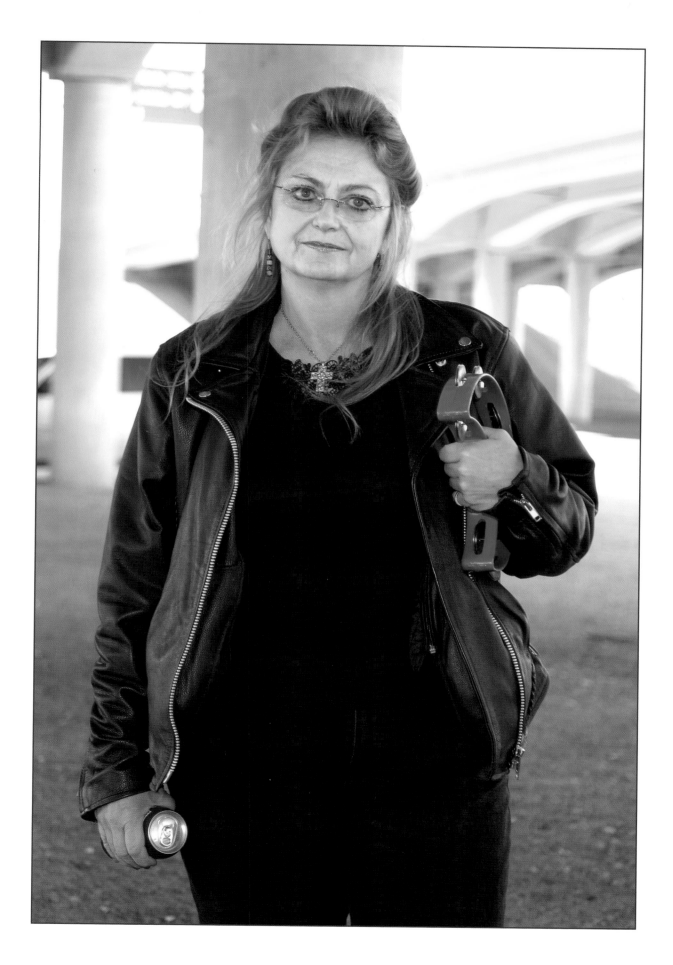

Glenn Bryant

Train Rider & Hobo
Recovering Alcoholic
2008, photograph 2010

"Train riding, that's an addiction, I did it 24/7 for 38 years.
My breed is becoming extinct. I started out in '69, became
a hippie, then I just never stopped traveling so I just kept
going. Mexico, Canada, and every state in the United States,
several times over. That was my way of life.

I keep a Marlboro backpack and a Walmart sleeping bag. I
learned early in my travels that I liked to stay warm and I
have always carried clean clothes with me. And it's easier to
carry a backpack than a suitcase. These are the tools of my
trade.

That's why they kept it locked up (My Brother's Keeper
Homeless Shelter), so I had to talk to them before I left."

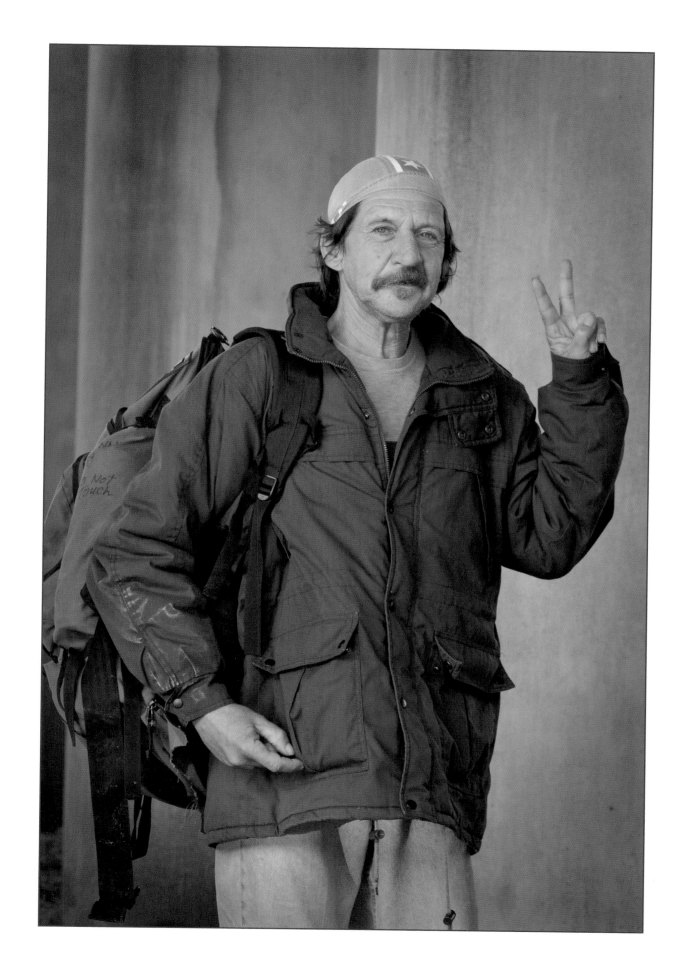

William Crowley

Veteran
Homeless
2010, *d. 2010*

"I keep my military ID with me always. They can always tell. They can always run it through the computer and tell all my illnesses.

I say, if you're in midstream you have to keep swimming."

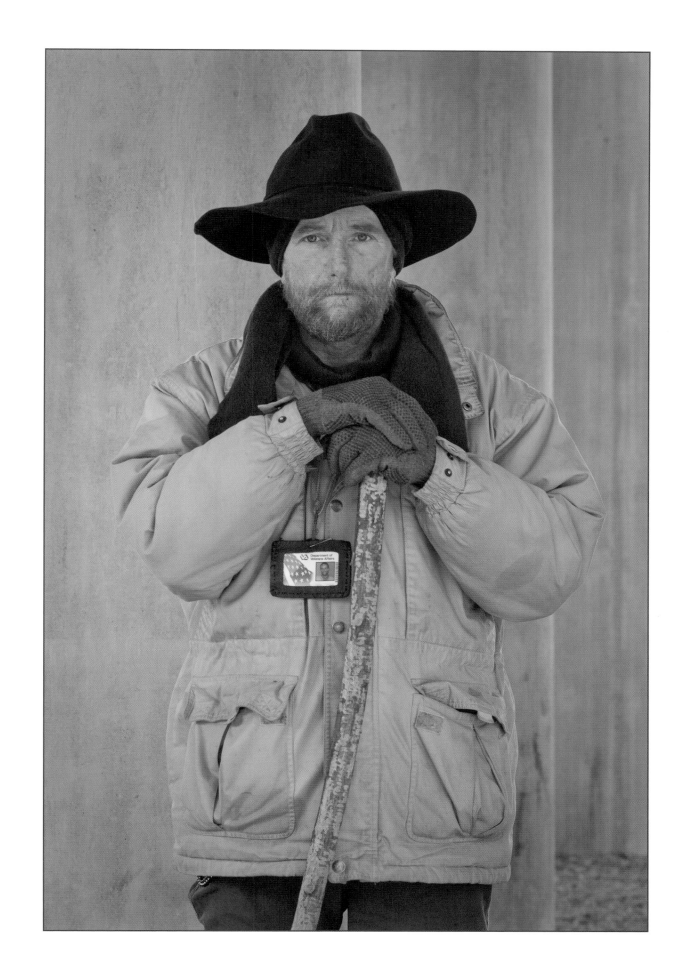

Shirley Austin

Domestic Worker
2008

"I have my stuffed animals. They're dear to me cuz I had them so long. I have this big old ugly bear. Because it's precious to me and I love it so much. People wants it but I won't give it away. When I move again I'm going to take it with me.

I went to a garage sale and I bought it for 25 cents and it's been special to me ever since. I just love it to death. I talks to it. 'You ugly but Momma loves you.' That's what I say to it."

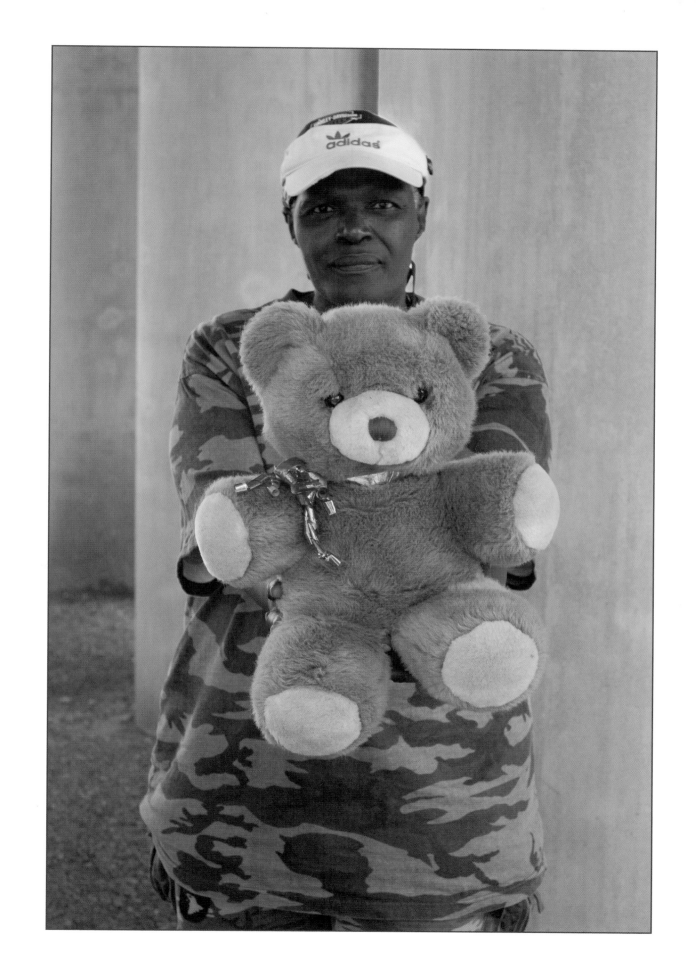

John Attaway

Retired Truck Driver
Homeless
2007, *d. 2009*

"That was my daddy's knife and I wouldn't take $500 for it.
When he passed away I got the knife. He gave 35 cents for
it in the early 1900s; he had it before I was born. I wouldn't
loan it to nobody or nothing like that.

I was a truck driver for 42 years — coast to coast — and
some local. I've been here since 1932."

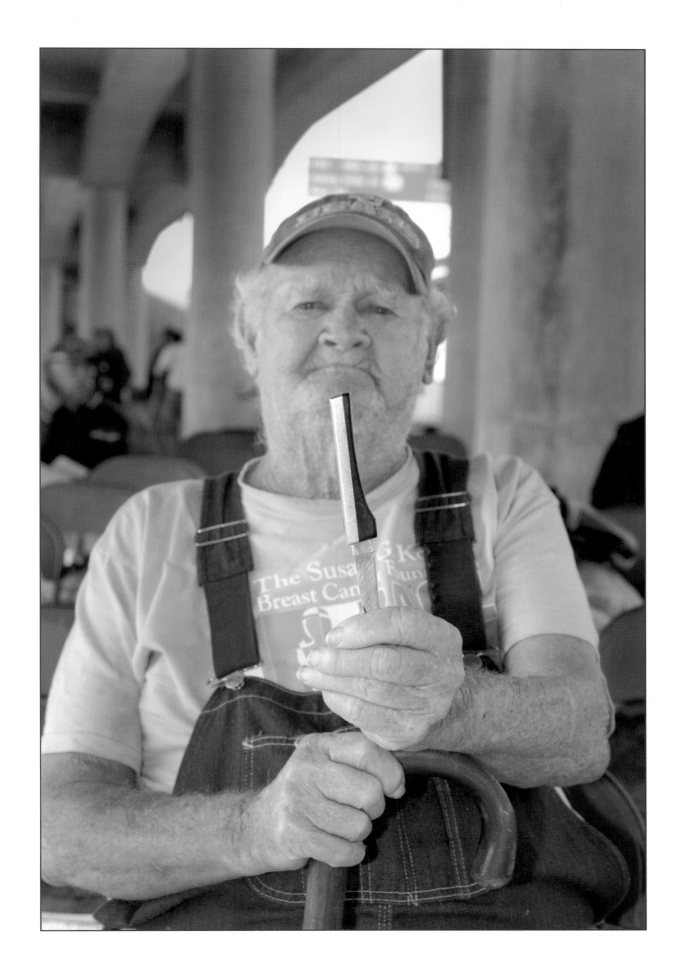

Roy Washburn

Small Engine Mechanic
Former Inmate
2007

"I've been thinking about it and I can't think of anything I can't do without."

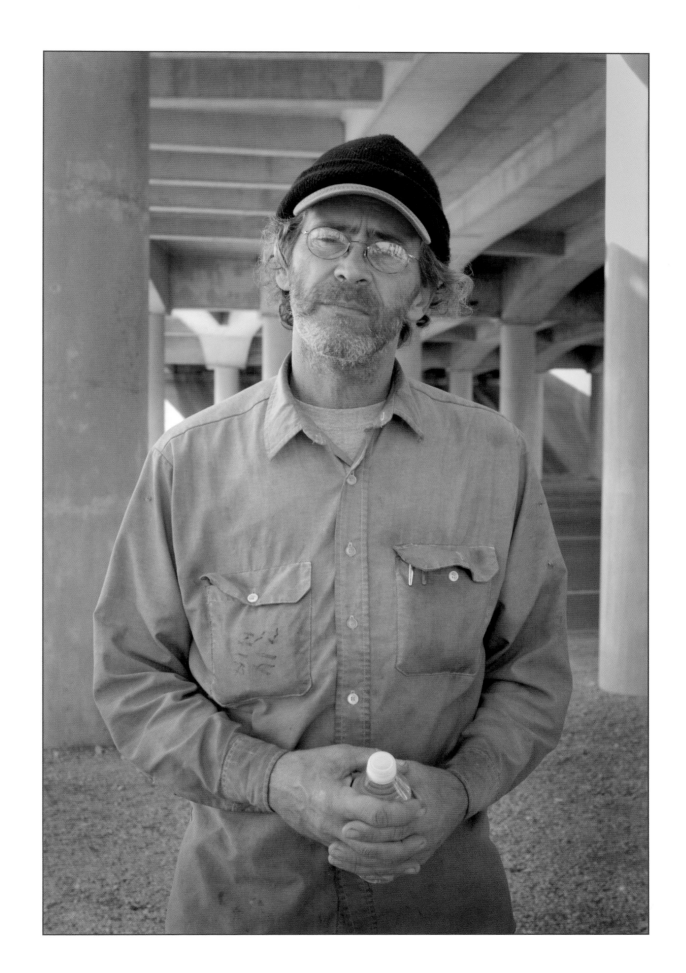